Paul Cézanne

Life and Work

Nicola Nonhoff

KÖNEMANN

Early Years
Page 6

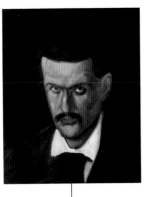

Apprenticeship
Page 12

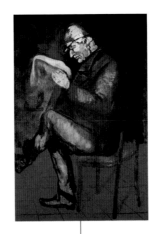

Early Works
Page 22

1839	1855	1860
1885	1890	1895

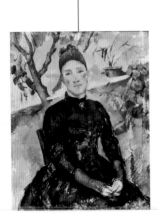

His Own Path
Page 48

Initial Recognition
Page 62

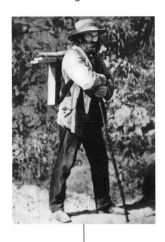
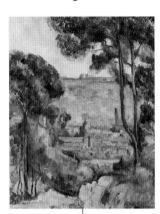
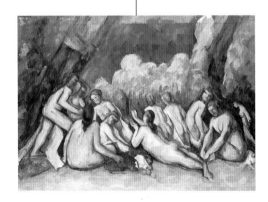

Early Years

It is not clear if Paul Cézanne painted as a small child. As a schoolboy he was interested mainly in literature and in his own attempts at verse. The earliest drawings to have survived were not produced until after his schooldays. If he did have artistic leanings, they were certainly not encouraged by his parents.

However, the many discussions with his close schoolfriend, Emile Zola, were an early stimulus for his imagination. The two young friends explored the region of Provence together on long excursions, and throughout his life the painter would feel closely linked to this landscape. In later life, Cézanne returned again and again to the themes of his childhood – the quarries that he and Zola walked through, the groups of bathers they saw, and the outline of nearby Mount Sainte-Victoire, the peak of a range of low mountains.

Telegraph Transmission, 1845

Portrait of Cézanne's Sister, Marie, ca. 1866

1840 Birth of the writer Emile Zola. Great Britain takes Hong Kong.

1842 The first telegram is sent.

1845 First performance of Richard Wagner's opera *Tannhäuser*.

1847 France completes the subjugation of Algeria

1848 Karl Marx and Friedrich Engels: *Communist Manifesto*. Near-revolutionary unrest in Berlin.

1851 First World Exhibition, in London.

1852 The French President Louis Charles Bonaparte is crowned Emperor Napoleon III.

1853 Start of the Crimean War.

1857 First world economic crisis. Charles Baudelaire: *Les Fleurs du mal*.

1839 Paul Cézanne born an illegitimate child at 28 Rue de l'Opéra, Aix-en-Provence.

1844 Parents marry in Aix-en-Provence.

1848 Birth of his sister Marie. Cézanne's father founded the Cézanne & Cabassol Bank with a colleague at 24 rue des Cordeliers.

1852 Cézanne attends the Collège Bourbon (today's Lycée Mignet).

1854 Birth of Cézanne's sister Rose.

1857 Cézanne enrolls in the local authority drawing class.

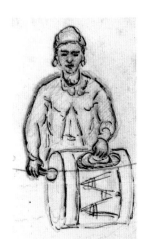

Opposite:
Self-Portrait
1862–1864
Oil on canvas
47 x 37 cm
Paris, private collection

Right:
Drummer Boy (detail)
ca. 1866
Charcoal on paper
Aix-en-Provence, Granet Museum

Childhood

Paul Cézanne was born on January 19, 1839, in Aix-en-Provence in southern France. His parents, the hat importer Louis-Auguste Cézanne and his former employee Anne-Elisabeth-Honorine Aubert, the daughter of a wood turner from Marseilles, did not marry until 1844, five years after Paul's birth. The youngest child, Rose, was born in 1854. Though Cézanne was not understood by his father, who thought him willful, he was always close to his mother.

The family lived in the best part of town, now known as the Cours Mirabeau, where Louis-August Cézanne, a successful trader, had set up business. Besides his trade in rabbit pelts and hats, he also lent money, and at the age of 50 he decided to turn this profitable sideline into his main occupation. In 1859 he opened his own bank and quickly became one of the wealthiest citizens of Aix-en-Provence.

So Paul Cézanne grew up in comfortable circumstances, though the family seems to have been treated as

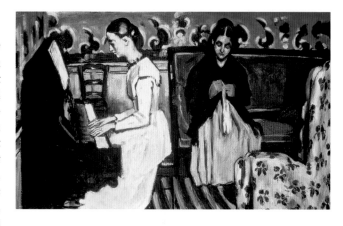

Young Woman at the Piano (The Tannhäuser Overture) (detail)
ca. 1869–1870
Oil on canvas
57 x 92 cm
St. Petersburg,
Hermitage Museum

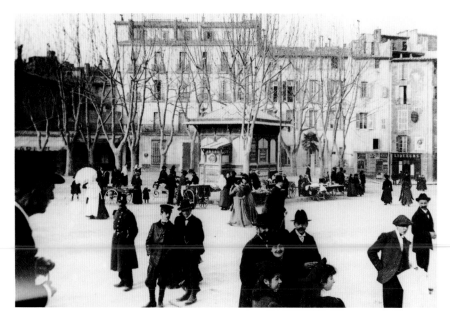

Aix-en-Provence
Place Jeanne d'Arc
Photograph, ca. 1900

outsiders. The "social climbing" banker from a modest background was not accepted by the upper middle classes. This experience of social isolation seems to have made a deep impression on Cézanne.

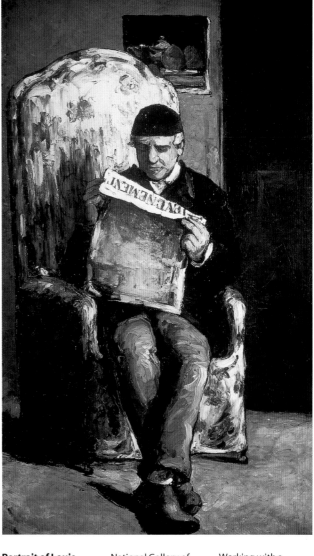

Portrait of the Artist's Mother
1869–1870
Oil on canvas
53.5 x 57 cm
Saint Louis, The Saint Louis Art Museum

The woman depicted here is presumably Cézanne's mother, of whom no other portrait by Cézanne is known. As with many of his paintings dating from between 1866 and 1868, the paint was applied with a palette knife, so that the ridges and contours of the individual colors are visible and imbue the static subject with life.

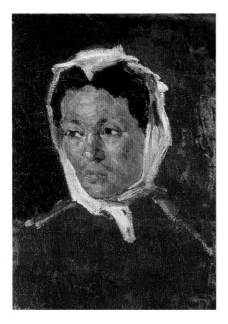

Portrait of Louis-Auguste Cézanne Reading *L'Evénement*
1866
Oil on canvas
200 x 120 cm
Washington, National Gallery of Art

This portrait of Cézanne's father is the most important of the paintings he executed in 1866.

Working with a palette knife, he not only emphasized the handcrafted nature of the work, but also gave expression to his intense temperament.

The "Inseparables"

As a schoolboy, Paul Cézanne was remarkable not for any artistic gifts but for his love of classical languages. According to one anecdote, he was supposed to have translated one hundred lines of Latin for two sous (a few cents). While he often won prizes for his achievements in Mathematics, Greek, and History, he only once received a commendation for Art. In the most sought-after school in Aix-en-Provence, the Collège Bourbon, he became a friend of Emile Zola, who was one year younger than Cézanne; Zola would become one of the best-known French writers of his age. Another school contemporary, Jean-Baptiste Baille, also joined the two friends. The "Inseparables," as the three were called, often went on trips into the area around Aix-en-Provence, to bathe in summer and to hunt in winter. But they also used these walks as an opportunity to relax in the open air and to indulge in long conversations.

Later, Zola recalled his youth with a certain sadness: "In the morning we used to leave the house before dawn. I would creep under your window and wake you at the dead of night. We would quickly leave the town behind us, our hunting bags on our backs, our guns in our hands. When we returned, the hunting bags may well have been empty, but our hearts and minds were full of what we had seen."

The conversations were invariably about the arts, though at this

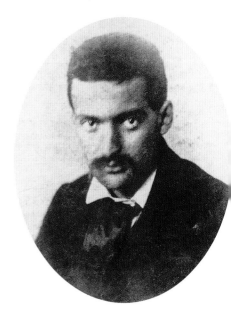

Right:
Paul Cézanne
Photograph, 1861

Below left:
Emile Zola
Photograph, 1865

Below right:
Jean Baptiste Baille
Photograph, 1862

Cézanne used this photograph of himself, taken when he was 22, for his first known Self-Portrait (page 6). Émile Zola, born in Paris in 1840, an engineer's son, went to the same school as Cézanne. Émile and his mother had to move back to Paris for financial reasons after his father's death in 1858. The third and youngest of the friends, Baptiste Baille, studied physics and later directed a company making optical equipment.

period it was still literature that interested them most; they were passionate about the Romantic authors popular at the time, Victor Hugo and Alfred de Musset, and both of the young friends wrote poetry. Zola, who found his friend's verse far more poetic than his own,

often encouraged Cézanne to persist with his poetry.

Their shared youth in Aix-en-Provence was abruptly cut short by Zola's move to Paris in 1858. From then on, the three dreamed of meeting in Paris after their baccalaureate. Zola, who had traveled to Paris with high expectations, had to struggle hard before he was able to take up his first position with the publishers Hachette, after a year out of work. In numerous letters, Zola entreated Cézanne to join him as quickly as possible. Nevertheless, it would be several years before the friends were reunited in Paris.

Above:
The Region Around Aix
Photograph, ca. 1900

We wanted to explore the depths of the heart and of the spirit.

Emile Zola to Jean Baptiste Baille

Diving Into Water
1867–1870
Chalk, watercolor, and gouache
15.5 x 16.2 cm
Cardiff, National Museum of Wales

This early study is one of Cézanne's first surviving attempts to handle the theme of the relationship between man and nature through a portrayal of a bather.

The man diving into the water is depicted at the very moment he comes into contact with the surface of the water, and yet there are no dramatic effects. The blue tones of the water, with the emphatic white reflections of light, give a static impression rather than one of movement, and the black lines following the contours of the body detach the body from the background. The impression of depth here results solely from the sharp definition of the various bright patches. The section of woodland seems further away than the bright water, but closer than the deep blue sky.

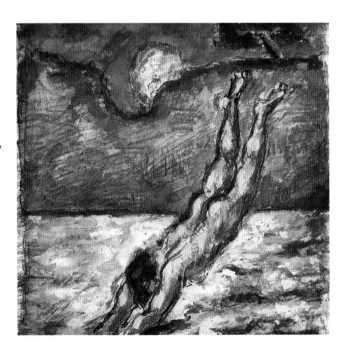

Apprenticeship 1858–1864

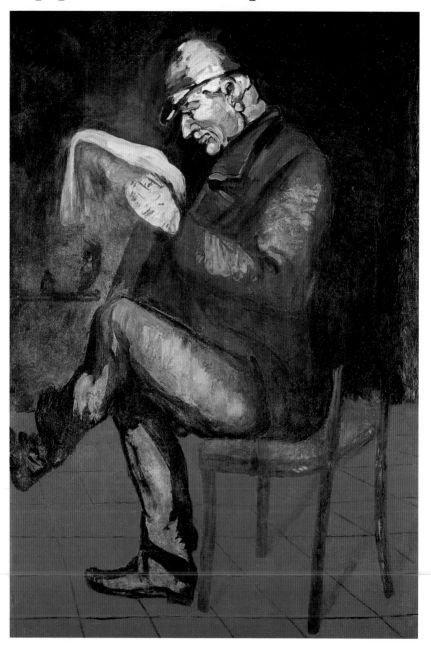

The earliest of Cézanne's surviving drawings date from the period just after he left school, when he had still not firmly decided to be a painter. It took him several years to overcome his own doubts and also to persuade his authoritarian father to allow him to study to be an artist.

Strictly speaking, Cézanne never had any training as an artist, at least in the academic sense, as he was repeatedly turned down by the École des Beaux-Arts, the university for fine arts in Paris. After attending several sketching courses in Aix-en-Provence, he finally went to Paris, where he attended life classes at the Académie Suisse, and got to know the avant-garde artists of the day. In the afternoons he copied Old Masters in the Louvre, mainly Rubens, and developed a great admiration for the most important of the French Romantic painters, Eugène Delacroix.

Karl Marx, ca. 1858

Portrait of Uncle Dominique, ca. 1866

1858 Attempt on the life of the French Emperor Napoleon III.

1859 First important work from Karl Marx: *A Critique of Political Economy.*

1860 The political leader Giuseppe Garibaldi drives the Bourbons from Sicily. Unification of Italy under Victor Emmanuel II.

1861 Abraham Lincoln becomes President of the USA. American Civil War begins.

1862 Victor Hugo's: *Les Misérables* is published.

1864 Foundation of the International Red Cross.

1858 Zola moves back to his mother in Paris. At his second attempt, Cézanne passes his school final exams with a mediocre mark. He enrolls in a law course in Aix-en-Provence Free School.

1859 Cézanne receives second prize at the School with a life-size study in oil of the head of a live model. In September his father buys the Jas de Bouffan property.

1860 Cézanne works at his father's bank in addition to studying.

1861 On April 21 Cézanne leaves Aix accompanied by his father to study in Paris.

1863 Cézanne exhibits at the Salon des Réfusés.

Opposite:
Portrait of Louis-Auguste Cézanne
ca. 1865
Oil on canvas
167.6 x 114.3
London, National Gallery

Right:
Portrait of Eugène Delacroix
1864–1866
Pencil and black chalk on paper.
14 x 13 cm
Avignon, Calvet Museum

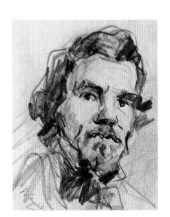

Murals for the Jas de Bouffan

In 1859 Louis-Auguste Cézanne bought the Jas de Bouffan, two kilometers west of Aix-en-Provence, as a summer residence. Completely derelict, this 18th-century country house had originally been the residence of the governor of Provence, the Duc de Villars, Marshall of France under the Sun King, Louis XIV. Cézanne's true home, where he spent some of the most important years of his life, the Jas de Bouffan, was also the place where he painted his first works. His father, who carried out only basic restoration on the neglected house, furnished it modestly, and allowed his son to paint large murals in the salon on the ground floor.

The Jas de Bouffan
Photograph

This imposing country house also had 15 hectares (37 acres) of vineyards and meadowland.

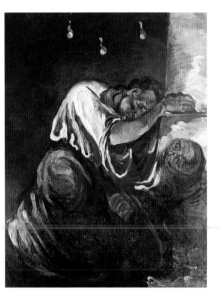

Mary Magdalene (Mourning)
Oil on canvas
165 x 124 cm
Paris, Musée d'Orsay

In the Louvre, Cézanne saw drawings and paintings by Old Masters. The *Allegory of Melancholy* by the Italian Baroque painter Domenico Fetti (1588/9–1622) was the inspiration for this painting. Cézanne paid particular attention to the details of the folds, using strong contrast of light and dark.

On four panels over three meters (well over ten feet) high in a semi-circular niche in the salon, Cézanne painted allegories of the four seasons, a traditional theme that he had found in books on Renaissance painting. Neither the style of the figures nor the technique are to be found again in Cézanne's works. Even the portrait of his father (page 12), painted only a few years later, and independently of the *Four Seasons*, shows a completely different style. This portrait was hung as the central image in the salon, between the allegories, and with its dark tones and visibly broader brush strokes is far more characteristic of Cézanne's early work.

All the murals have been transferred to canvas and distributed to various museums. The same applies to all the pictures created in the salon over the next ten years. On the left-hand wall there was a back-view

of a nude bather, and on the right a landscape with fishermen, a painting later discovered under the wallpaper. A large composition, split into two sections, represented the grieving Mary Magdalene on one side and Christ in Purgatory on the other.

The choice of subject makes it clear that at this time – as in subsequent years – the young artist often dealt with traditional art themes, but interpreted them in his idiosyncratic way. The painting of Mary Magdalene (opposite), for example, represents his personal confrontation with the theme of grief, whereas in the depiction of Christ in Purgatory he used a composition taken from the Italian Renaissance painter Sebastiano del Piombo (ca. 1485–1547), probably known to Cézanne through reproductions.

Autumn
1860–1861
Oil on plaster, transferred to canvas
314 x 104 cm
Paris, Petit Palais

The Salon, the Jas de Bouffan, with Cézanne's frescoes of the Four Seasons and the *Portrait of Louis-Auguste Cézanne*
Photograph ca. 1936

The arrangement of the paintings, which does not follow that of the seasons of the year, leads to the conclusion that Cézanne began with the two inner pictures, *Summer* and *Winter*, and decided later to paint *Spring* and *Autumn* as well.

Legal Studies and Painting

Only one year after his baccalaureate, Cézanne appears to have seriously considered dedicating himself to painting. But he obviously could not persuade his father to agree to this. Torn between his father's desire for him to embark on a respectable career and his own longing to be an artist, Cézanne reluctantly enrolled, at his father's request, at the law faculty in Aix-en-Provence. But as soon as his course of legal studies began he complained bitterly.

In the evenings he went to drawing classes run by the local authority, where, under the free tuition of his teacher, Gilbert, he copied plaster casts and drew life studies. In the museum in Aix-en-Provence he copied innumerable Old Masters – sketches he would refer back to throughout his life, whenever he was painting the human form without a model. In 1859 he was awarded his only prize: second prize for a painting of a life-class study.

It was only at the insistence of Zola, who wanted Cézanne to join him in Paris, that he finally summoned the courage to ask his father for financial support to study art. In April 1861 Cézanne traveled to Paris, full of anticipation. But the long-awaited period in the big city was to be the unhappiest period of his life.

In Paris he worked regularly at the Académie Suisse, a private college, where no instruction was given, but where male and female models were available to the artists for a small fee. Soon, however, dissatisfied with his progress, Cézanne started to doubt his abilities. Zola reported to his childhood friend Baille: "To convince Cézanne about something is about the same as getting the

Louis-Auguste Cézanne
Photograph

Cézanne's father, a successful merchant and banker, had little understanding for the artistic interests of his son, whose professional future he saw at the bank.

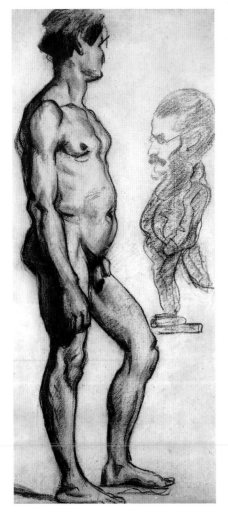

Left:
Male Nude
1865–1866
Charcoal on paper
50.2 x 30 cm
Private collection

In his first drawings, which he drew from life at the Aix drawing school, Cézanne concentrated on accurate detail and finely drawn studies with shading providing a three-dimensional effect. In his later works on paper, executed at the Académie Suisse in Paris, he distanced himself from this traditional type of drawing.

towers of Notre Dame to dance the quadrille. He is totally stolid, obstinate, and immovable."

Discouraged, Cézanne decided to leave Paris only a few weeks after his arrival. Zola managed to get him to stay a few more months in Paris through a ruse: he suggested his friend paint a portrait of him. Cézanne got down to work with renewed enthusiasm, but made little progress. By the fall of the same year he had had enough.

He traveled back to Aix-en-Provence and began working in his

Portrait of Emile Zola
1862–1864
Oil on canvas
26 x 21 cm

This unfinished portrait represents Cézanne's friend lost in thought and concentration. When Cézanne had wanted to leave Paris soon after arriving, Zola persuaded him to paint his portrait. However, after only a few sittings, Cézanne gave up and returned to Aix-en-Provence.

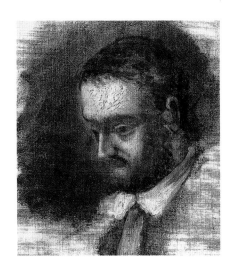

Boys Bathing
Sketch in a letter to Zola
June 20, 1859

The first drawing we have of Cézanne's was on the last page of a letter addressed to Zola. In memory of the bathing excursions as boys, the three figures bathing probably represent Zola, Baille, and Cézanne himself, "The Inseparables."

father's bank, bitterly disappointed by his failure. However, it was not long before he found that he was totally unsuited to working in a bank. He wrote his ironic confession in the bank's main ledger, in a couplet: "Banker Cézanne sees, with fear I reckon, A painter at his counter beckon."

Even his father now accepted that his son would never succeed him in the business, and gave him permission to concentrate on painting. Nevertheless, he insisted that his son should apply to the official university art school, the establishment École des Beaux-Arts in Paris. So Cézanne traveled for the second time to Paris, with a modest monthly allowance of 150 francs.

Just don't imagine that I will become a Parisian

Cézanne in a letter to Joseph Huot

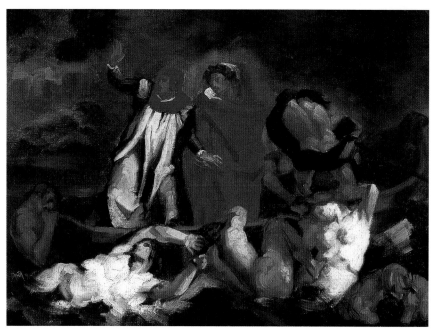

The Barque of Dante
After Delacroix
ca. 1870
25 x 33 cm
Cambridge,
Massachusetts
Private collection

In November 1863, Cézanne had received permission to copy paintings in the Louvre. This masterpiece by Delacroix was frequently copied at this period. It was rare for Cézanne to keep as close to the original as on this occasion, which is the earliest extant example of a copy of Delacroix in Cézanne's work.

Studies in Paris

In the autumn of 1862, and now with the firm intention of becoming a painter, Cézanne traveled to Paris for the second time. This time, too, he worked regularly at the Académie Suisse on the Quai des Orfèvres. The independent Académie Suisse was a focus for painters who had been rejected by the establishment École des Beaux-Arts, or who had themselves rejected the traditional taste in art. Here, in addition to old acquaintances such as his friend from Aix-en-Provence Achille Emperaire, Cézanne again met Camille Pissarro, who was later to introduce him to painting in the open air. Here he also got to know Auguste Renoir, Alfred Sisley, and Edouard Manet, artists who shortly afterwards became known as the Impressionists.

As his father wanted to see him studying at the École des Beaux-Arts, Cézanne handed in his application to study there, but was rejected. Cézanne's disappointment was obviously not very deep, for the conservative professors there were well known for their intolerance towards

Eugène Delacroix
The Barque of Dante
1822
Oil on canvas
189 x 246 cm
Paris, Louvre

With this painting Delacroix had made sure of acclaim at the 1822 Salon. He used the typical genre of historical painting, such as the pyramid picture composition stressing the main figures.

In this scene from Dante's epic *The Divine Comedy*, Dante and Virgil are crossing the Acheron in order to reach the first region of Hell.

any form of artistic innovation. Official teaching was still centered on the ideal of beauty as represented in the painting of Jean-Auguste-Dominique Ingres (1780–1867), the leading Neoclassicist of the first half of the 19th century. Ingres, who detested both improvisation and inexact draftsmanship, had insisted on his pupils making very careful drawings.

Cézanne felt drawn to Eugène Delacroix, who for years had been the main opponent of Ingres. In contrast to the cool, classical mood of Ingres' paintings, the paintings by the leader of the Romantic movement showed scenes full of movement, passion, and drama. For Delacroix, the principal element of painting was not technical perfection but color. Cézanne copied six of Delacroix' paintings alone, and in addition made innumerable sketches of his works and variations on their themes.

Delacroix had a direct influence on Cézanne's palette, with colors such as purple, Veronese green, and Prussian blue now dominating.

In addition to Delacroix, Cézanne also drew a great deal of inspiration during these years from a group of young painters who had gathered around Gustave Courbet. The so-called Realists, whose work at the Académie Suisse had to be vehemently defended against outraged public opinion, sought their subjects in everyday life, their aim being to reproduce reality as directly as possible. Their subjects were in stark contrast to the refined or edifying subjects recommended to students at the École des Beaux-Arts.

Jean-Auguste-Dominique Ingres
Bather at Valpinçon
1808
Oil on canvas
146 x 98 cm
Paris, Louvre

This female nude is one of the major works by Ingres, one of the most famous and influential French Neoclassical painters.

Gustave Courbet
The Coast near Étretat after a Storm
1869
Oil on canvas
133 x 162 cm
Paris, Musée d'Orsay

Like Cézanne, Gustave Courbet (1819–1877) was close to the Impressionist painters, without however completely adopting their concern with representing light. Cézanne found great inspiration in Courbet's methods of applying color. Courbet, like Cézanne, applied paint with a palette knife and thus achieved a portrayal of the Atlantic coast near Étretat that gives a vivid impression of nature. The cloudy sky and the strongly contrasting light and shade impart energy to the apparently peaceful scene, and the impasto technique gives the separate elements of the painting a tactile quality.

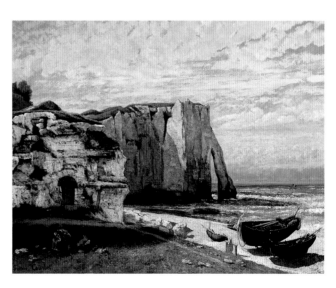

The Salon

It's the mediocre which is accepted. The walls are plastered with middle-class and completely undistinguished paintings. You can look from top to bottom, through and through: not one painting that shocks, not one painting that delights. They have cleaned up art, they have given it a good polish; a good citizen in slippers and a white shirt.

Emile Zola

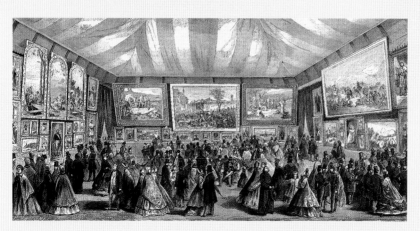

The official art exhibitions in 19th century Paris were known as the "Salons." Originally, this term had been used for the imposing reception rooms of a palace. During the 19th century, it was also used for a place where an exhibition was held, and then transferred to the exhibitions themselves.

Among the avant-garde artists of Cézanne's time, the official Salon was considered to be the stronghold of the traditional and the obsolete. This was because the selection jury, mostly members of the École des Beaux-Arts or the Académie, took the same conservative view of art as the official Académie and suppressed any attempts at innovation. The derogatory terms "Salon art" and "Salon painting," still used to this day, were derived from the official Salons to which access was denied for all members of the avant-garde. A painting such as *The Birth of Venus* (below) by

Above:
The Great Exhibition at the Palais de l'Industrie, 1863
Contemporary engraving

Alexandre Cabanel, which was exhibited in the 1863 Salon, was the kind of painting acceptable to the jury, since it dealt with a traditional mythological subject depicted in the approved, highly finished academic style.

Writing as an art critic, Zola, who tried to draw public attention to the new trends in contemporary painting, was quick to satirize the Salon. During his account of the Paris Salon of 1866, he described the members of the jury as: "… those charming colleagues who reject or accept with indifference; the successful, whose battles are behind them; yesterday's artists who cling to their opinions and have no time for new approaches; and, finally, those of today's artists who have achieved modest successes with insignificant art and defend it with tooth and claw by cursing and threatening any of their fellow-artists in the vicinity."

At the Salon of 1863, the rejection of a large number of submitted paintings raised such a storm of protest among the artists and in the press, that Emperor Napoleon himself

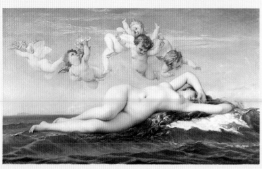

Alexandre Cabanel
The Birth of Venus
1863 (salon)
Oil on canvas
130 x 225 cm
Paris, Musée d'Orsay

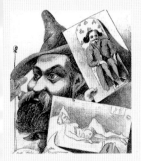

Album Stock
Caricature of Cézanne with both of the paintings rejected by the jury of the 1870 exhibition.

The Cemetery of the Rejected
19th-century etching

arranged for the rejected works to be exhibited in another part of the Palais de l'Industrie, so that the public could "form an impression of how justified these protests are."

This "Salon des Réfusés" (Salon of the Rejected), as it is known in art history, caused no less a scandal itself. The visitors to the exhibition, used to the traditional art of the Académie, were overwhelmed by the paintings shown – there were works by Manet, Pissarro, Jongkind, Guillaumin, Whistler, Fantin-Latour and others – and by the completely unknown "modern" trends these works represented. The press subjected the Salon des Réfusés to a barrage of criticism and abuse.

Cézanne was also one of the "rejected," and for him, the Salon des Réfusés was his first opportunity to exhibit his work to the public. Unfortunately, there is no mention of his work in the catalogue, so that we can no longer tell which paintings he exhibited. The Salon des Réfusés of 1863 was never repeated, so in subsequent years progressive artists had no alternative but to submit their work as usual to the official Salon and await the jury's verdict. But the rejected works had attracted a great deal of public attention, as a caricature of Cézanne, then an almost unknown painter in Paris, clearly shows. He is shown with two of his paintings, both of which had been rejected in 1870.

Not until 1884, with the Salon des Indépendants, was an annual exhibition independent of the jury of the École des Beaux-Arts established in Paris.

Portrait of Achille Emperaire
1867–1868
Oil on canvas
200 x 122 cm
Paris, Musée d'Orsay

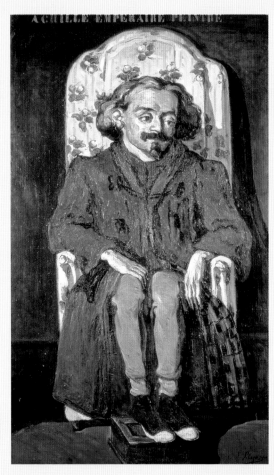

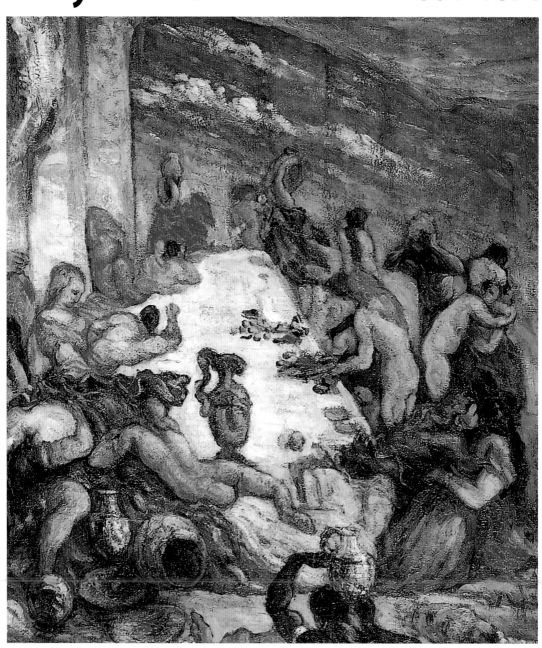

Cézanne's works from the second half of the 1860s are dominated by highly original variations on a traditional theme: the battle of the sexes. The intensity of these paintings, it is wide agreed, strongly suggest that Cézanne was struggling to come to terms with a deep-seated fear of women, for they are permeated with an air of decadence, aggression, and eroticism.

By the end of the decade, however, these depictions of often brutal force had largely been replaced by landscapes – landscapes, moreover, that seem to suggest that his turbulent obsessions had begun to ease. In fact, the earlier drama of action had been exchanged for a no less disturbing mood of subdued excitement. Women are now represented as temptresses, a theme Cézanne worked on until well into the 1870s. He sent paintings to the official Salon almost every year, but they were always rejected.

Opening of the Suez Canal, 1869

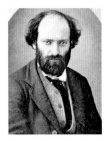

Cézanne in 1871

1865 End of the Civil War in the USA. Abolition of slavery.

1867 Death of Charles Baudelaire.

1870 Beginning of the Franco-Prussian War. Battle of Sedan.

1871 Peace treaty between France and Germany. Alsace-Lorraine goes to Germany. First performance of *Aida* by Giuseppe Verdi. First volume of Zola's series of novels *Les Rougon-Macquart.*

1864 Cézanne's paintings are rejected by the Salon.

1865 He spends most of the year in Paris, and the summer in Aix-en-Provence. This year too, his paintings are rejected by the Salon.

1866 In spite of recommendations, he is again rejected by the Salon, upon which he writes a letter of protest to the Director of the École des Beaux-Arts.

1868 In Aix-en-Provence from May till December, he works at the Jas de Bouffan.

1869 Meets Hortense Fiquet.

1870 Avoiding the draft, he goes first to Aix-en-Provence and then travels on to L'Estaque, where he lives with Hortense till March 1871.

Opposite:
**The Orgy
(The Banquet)** (detail)
ca. 1867
Oil on canvas
130 x 81 cm
Paris, Private collection

Right:
Portrait of Achille Emperaire
1868–1870
Charcoal on paper
48.4 x 31.8 cm
Paris, Louvre
Drawings Collection

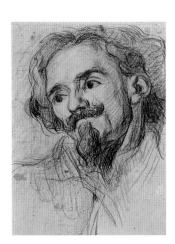

Violence and Sexuality in the Early Work

These somber paintings, which were executed during his first years in Paris, form a distinct group. For his themes, Cézanne was still using the traditional subjects provided by the paintings he saw in the Louvre or in books. Thus his subjects were mainly literary, mythological or biblical, though he re-worked them in a highly individual and dramatic style. Aggression and brutality dominate these works, their subjects being sex, seduction, kidnapping, and murder.

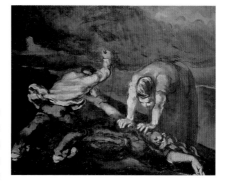

The Murder, ca. 1870
Oil on canvas
65 x 80 cm
Liverpool, National Museums and Galleries on Merseyside, Walker Art Gallery

Without relating this act to a specific traditional subject, Cézanne depicts raw, uninhibited violence.

Mostly restricted to strong, dark colors, these paintings generally depict two or three figures, the woman always being shown in one of two roles: either the victim or the seducer. Cézanne stressed the brutality of the events portrayed through

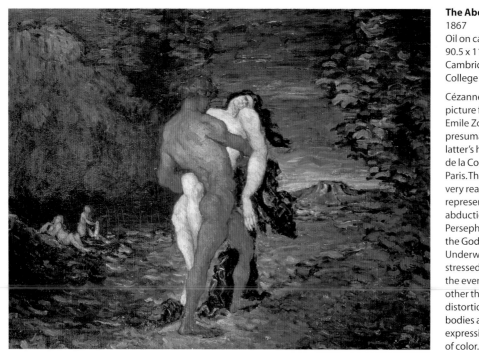

The Abduction
1867
Oil on canvas
90.5 x 117 cm
Cambridge, King's College

Cézanne painted this picture for his friend Emile Zola, presumably in the latter's house in Rue de la Condamine in Paris. The subject is a very realistic representation of the abduction of Persephone by Hades, the God of the Underworld. Cézanne stressed the drama of the event by, among other things, the distortion of the bodies and the expressive use of color.

Lot and his Daughters, ca. 1865
Oil on canvas
23.6 x 28.7 cm
Los Angeles, Private collection

Cézanne used the biblical story of the abduction of Lot by his daughters as a direct representation

of sexuality. The harmonious effect of the color contrasts sharply with the nature of the scene and has a three-dimensional effect, lifting the figures out of the dark background.

Temptation of Saint Anthony
ca. 1870
Oil on canvas
57 x 76 cm
Zürich, E.G. Bührle Collection

As with the other paintings from this period, the *Temptation of Saint Anthony* is restricted to very dark colors that stress the hellish and compromising situation the saintly monk finds himself in. Here, Cézanne used a traditional religious theme to give free rein to his own innermost fears and passions.

the distortions of the figures' bodies and the oppressively confined spaces they inhabit. Strong contrasts of light and dark heighten the emotion, and restless, erratic brushstrokes emphasize the agitation of the scenes.

These images are widely seen as reflections of Cézanne's sexual fears and confusions. We know from several sources that he was timid and shrank from any form of physical contact, especially with women. It is difficult, in the absence of intimate biographical details, to establish precisely what caused these feelings. The paintings themselves, however, are an eloquent and disturbing testimony to his torments and obsessions.

Dispute with Manet

After the disturbing works of the 1860s, between 1869 and 1871 Cézanne painted a series of landscapes with figures. In these, though the problematical relationship between the sexes is still evident, the stress is now on reconciliation through women. Yet even though the aggression of the protagonists has given way to a certain passivity and repose, these works still convey a strangely disturbing mood.

One of the most prominent personalities of the Paris art scene of the 1870s was the painter Edouard Manet (1832–1883). His paintings shocked the conservative visitors to the Salon, but greatly impressed young artists. Cézanne also admired his work, but he was not particularly attracted to the artist himself, whose conceited manner at the regular meetings of artists in the Café Guerbois in Paris he disliked intensely. At their first meeting in 1866, Manet, who was six years older than Cézanne, had praised one of his still lifes highly, but had then, behind his back, dismissed him as merely an "interesting colorist."

While Cézanne therefore avoided personal contact with Manet, he nevertheless studied his paintings very closely. In two paintings of this period, he made direct reference to important paintings by Manet, *Olympia* (right) and the *Déjeuner sur l'herbe* (opposite, below), both of which had caused a scandal the previous year. Cézanne's variation

A Modern Olympia
1869–1870
Oil on canvas
56 x 55 cm
Paris, Private collection

In contrast to Manet's *Olympia*, Cézanne's version contains a self-portrait, as do many of his early erotic works. The immediacy with which the courtesan offers herself in Manet's painting is tempered in Cézanne's painting by a drape, which acts as a frame, and by Olympia's frightened pose.

Below:
Edouard Manet
Olympia, 1863
Oil on canvas
130.5 x 190 cm
Paris, Musée d'Orsay

The representation of the female nude as a reclining Venus had been popular since the 16th century. Manet transferred the

subject to an everyday scene: he depicted a prostitute with direct, provocative gaze receiving a spray of flowers. The painting caused a scandal at the 1865 Salon and did not receive a place in the Louvre until 1907.

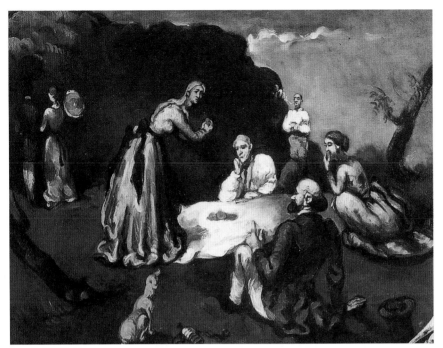

Le Déjeuner sur l'herbe, ca. 1870
60 x 81 cm
Paris, Private collection

Cézanne adopted the setting used by Manet in his picture of the same name: a picnic in the country. The individuals reclining around the tablecloth in frozen poses seem to be concentrating on the declarations of the standing woman with the unattractively lank hair.

With an apple, the symbol of seduction, in her hand and her gaze firmly fixed at the seated figure on the right: she is in effect addressing the artist himself, who has placed himself in the foreground of the painting, with his back to the observer. As with other idyllic scenes dealing with the relationship between the sexes executed by Cézanne in this period, the personal symbolism of this painting will never be unequivocally deciphered.

on Manet's *Olympia* became almost a parody of the original. Painted in strong colors and depicting bloated, contorted figures, Cézanne's painting confronts the sober restraint of Manet's composition with a provocatively sensual treatment of the subject. For Cézanne's at this time, the true artist distinguished himself by his passionate temperament. In the same way, by adopting themes of this kind he was in effect expressing his own modernity.

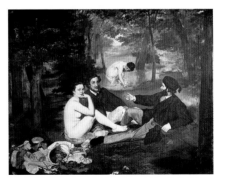

Edouard Manet
Le Déjeuner sur l'herbe
1863
Oil on canvas
214 x 270 cm
Paris, Louvre

Manet's representation of a country idyll in the woodland round Paris was seen as an attack on public decency. The artist was widely censured for depicting the everyday world in art and for breaking free of 19th-century social conventions.

Escape from War

In 1869 Cézanne met Hortense Fiquet, who was eleven years younger than he was; trained as a bookbinder, she was now working in Paris as a model. In 1870, to escape being drafted into the army on the outbreak of the Franco-Prussian War (July 1869–May 1871), Cézanne fled with Hortense to the small fishing village of L'Estaque close to Marseilles in southern France. Here he remained in hiding for the duration of the war.

In contrast to the expressive work of the previous ten years, which clearly expressed an intensely personal view of the relationship between the sexes, his paintings executed at L'Estaque were the result of his contact with the open countryside. He now needed to work outside his studio and to concentrate on the themes he found in his immediate environment: nature. In their coloration and their expressive brushstrokes, the works executed during this period in L'Estaque do not differ appreciably from his earlier paintings. But the emphasis on the

Cézanne's House in L'Estaque
Photograph, ca. 1910

Stubbornly refusing to be drafted into the army, Cézanne spent the winter of 1870–1871 with Hortense Fiquet in a small house in L'Estaque that his mother had bought.

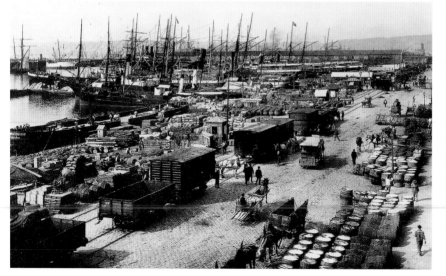

View of Marseilles Harbor
Photograph, ca. 1880

The busy harbor town of Marseilles, which was also important as a supply base during the Franco-Prussian War, is about 50 kilometers (31 miles) from L'Estaque. Although Cézanne did not particularly like this busy, industrial city, he frequently stayed there with his wife, Hortense.

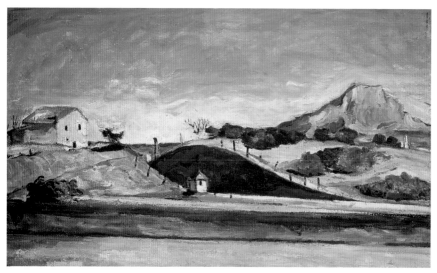

Railroad Cutting with Mont Sainte-Victoire, 1870
Oil on canvas
80 x 129 cm
Munich, Neue Pinakothek

Cézanne documented this railroad cutting with sober objectivity and without any indication of the criticism of industrial development that was already becoming apparent in many contemporary works of art.

close observation of nature represents a major turning point in Cézanne's artistic development. Over the next few years, landscape became his preferred subject and was to remain so for the rest of his life.

After the fall of the Paris Commune on May 1, 1871, Cézanne returned to the capital, where he took an apartment in the Rue de Chevreuse. Hortense came shortly after and the following year their son Paul was born.

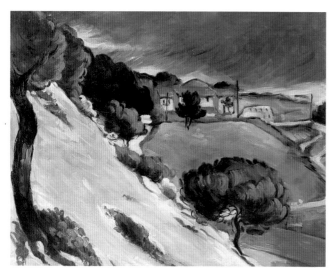

Thaw near L'Estaque
ca. 1870
Oil on canvas
73 x 95 cm
Zurich, E.G. Bührle Collection

This painting provides a graphic illustration of the transition from Cézanne's wildly expressive figure scenes to landscape painting. While the dark colors remain as an element of the artist's earlier dramatic period, the subject is now taken directly from nature. Nevertheless, with the theme of the thaw, he is creating an image of nature subject to a process of change, of movement. In his later paintings, by contrast, he depicted nature at peace with itself.

Impressionism 1872–1877

In 1872, Paul Cézanne took his small family to Pontoise, where he worked alongside Camille Pissarro, one of the early Impressionists. In just a few months, Cézanne, strongly influenced by Pissarro, began to take his subjects directly from nature, his aim being to capture as accurately as possible the impression they made on him. He now rejected not only the themes of his wildly expressive early period, but also his earlier painting techniques and somber colors.

What he learned from Pissarro – the use of brighter colors, the adoption of a regular brushstroke "signature," and the precise observation of nature – gave Cézanne a completely new artistic direction. His encounter with Pissarro and the Paris Impressionists was a critical moment in his development. By the end of this period Cézanne finally knew what he wanted to express in his painting.

Negotiations with the Sioux, ca. 1875

Cézanne, ca. 1875

1872 Military service is increased to five years in France.

1874 Modest Mussorgsky: *Pictures from an Exhibition*. Gustave Flaubert: *The Temptations of St. Anthony*.

1875 Beginning of modern bicycle production in England.

1876 Alexander Graham Bell patents his invention of the telephone. The last victory of the Native Americans against the US cavalry, at Little Big Horn.

1877 The beginning of color photography with the autochrome plate. Death of Gustave Courbet. The first Wimbledon tennis tournament.

1872 January 4: Cézanne's son Paul is born. Cézanne moves with his family to Pontoise and, towards the end of the year, to Auvers-sur-Oise.

1874 Takes part in the first Impressionist exhibition in Paris. He spends the summer in Aix-en-Provence.

1875 Meets Victor Chocquet.

1876 Takes part in the second Impressionist exhibition and again spends the summer in Aix-en-Provence.

1877 Spends almost the whole year in Paris and takes part in the third Impressionist exhibition.

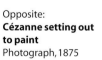

Opposite:
Cézanne setting out to paint
Photograph, 1875

Right:
Portrait of Camille Pissarro
1874–1877
Pencil on paper
21.3 x 12.9 cm
Paris, Louvre

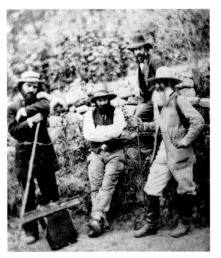

Pissarro

In the summer of 1872, Camille Pissarro (1830–1903), one of the early Impressionists, invited Cézanne to visit him in the town of Pontoise, to the northwest of Paris, in order to paint. Pissarro had already impressed Cézanne at the Académie Suisse as a highly gifted artist who would undoubtedly be successful. After his period of dark and disturbing figure paintings, Cézanne, now keen to develop his landscape painting after the time he had spent in L'Estaque, accepted the invitation, taking Hortense and their son Paul with him. This visit was to bring about the complete transformation of his style.

It was not merely from the artistic point of view that this prospect was beneficial. The oppressive closeness of the family life he was leading with Hortense in Paris after the birth of their son had, by February, tipped him into a deep depression.

In Pontoise, Pissarro, who was nine years older that Cézanne, instructed him in the precise observation of nature. They worked together in the open air and took what subject nature provided. Under his friend's influence, Cézanne worked with brighter colors and stopped using black; the use of color to achieve the most precise impression of nature would become increasingly important in his work. He also adopted Pissarro's technique of applying color with a series of small brushstrokes and dots.

In their attempt to reproduce an immediate impression of a landscape, the precise depiction of light was of particular importance. This was achieved by painting with short brushstrokes of graduated color placed close together, a technique that captures the subtle, shimmering

Paul Cézanne (2 from left) with Camille Pissarro (right) in the neighborhood of Auvers
Photograph, ca. 1877

Below:
Camille Pissarro
Country House at Pontoise, 1872
Oil on canvas
St. Gallen,
Kunstmuseum

In a harmonious and natural composition, Pissarro depicts a small property close to Pontoise. He creates the atmosphere of a spring day by means of intense color and strong contrasts of light and shade. The lightly applied brushstrokes give the painting an airy delicacy of atmosphere that Cézanne also tried to achieve.

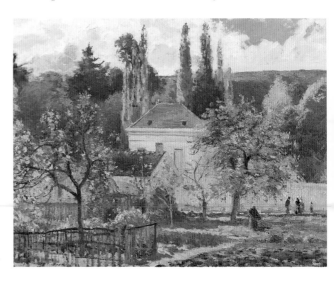

play of light across a landscape; the result is an accurate depiction of exactly how a sun-filled landscape looks to an observer. In the summer of 1872, and in the following years, Cézanne painted landscapes such as *The House of Père Lacroix, View of Auvers-sur-Oise,* and *Houses in Auvers* – paintings whose subtly harmonious colors produce a bright, airy mood close to that of Impressionist paintings. In later years Cézanne refined the brush technique Pissarro had taught him, producing a fine mosaic of regular, right-angled strokes that would characterize his work until the 1880s.

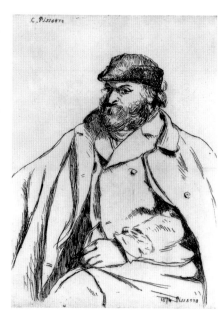

Camille Pissarro
Portrait of Paul Cézanne
1874
Etching
27 x 21 cm

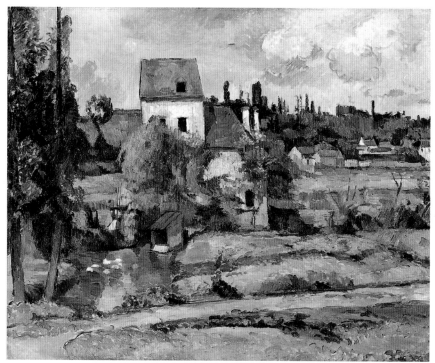

The Mill on the Couleuvre near Pontoise
1881
Oil on canvas
75.5 x 91.5 cm
Berlin, Staatliche Museen zu Berlin, Preussischer Kulturbesitz, Nationalgalerie

This mill, close to Pissarro's home in Pontoise, was a favorite subject for both painters. To reproduce the impression of fields bathed in sunlight, Cézanne dotted the green meadows with innumerable spots of white and bright colors.

Doctor Paul Gachet
Photograph, ca. 1880

Vincent van Gogh
Portrait of Père Tanguy
1887
Oil on canvas
92 x 75 cm
Paris, Musée Rodin

Cézanne's First Patrons

Cézanne was in his early 30s when he first met a series of loyal patrons. They were Doctor Paul Gachet, predominantly known in the history of art for his friendship with Vincent van Gogh (1853–1890), whom he treated over many years; Père Tanguy, a paint dealer who sold his customers' paintings; and Victor Chocquet, a customs' inspector who collected Impressionist art.

From the winter of 1872 until the spring of 1874, Cézanne lived, at the invitation of Doctor Gachet, in his house at Auvers-sur-Oise, close to Pontoise, where Pissarro was living. This eccentric doctor and art lover quickly became an admirer of Cézanne's work. After the two men had discussed Manet's *Olympia* and Cézanne's version of it (page 26),

Cézanne is said to have taken up his brush and, with a speed normally very unusual for him, executed a second version of his own *Olympia* for Doctor Gachet. It was the very first painting Cézanne sold to him.

Cézanne was introduced to Julien Tanguy by Pissarro when staying in Paris in 1873. Tanguy was to support him enthusiastically for decades. This paint dealer, who was known in art circles as Père (father) Tanguy, took the paintings of his painter friends, among them Pissarro, Sisley, van Gogh, Gauguin, Signac, and Seurat, in exchange for canvas and paint. And it was in this way that he made it possible for the financially insecure Cézanne to get the materials he needed for his work. The art dealer Ambroise Vollard recounted later that Tanguy would go with prospective buyers to Cézanne's atelier and would sell the paintings there for either 40 or 100 Francs, depending on their size. If these prices were still too high for the buyers, Tanguy would sell specific features of one of Cézanne's paintings, which he used to cut out with scissors!

During this period, Cézanne met another patron of contemporary art

with whom he formed a close friendship. Victor Chocquet, Chief Inspector with the Paris Customs Administration was, like Cézanne, a great admirer of the art of Eugène Delacroix, and his passion for collecting had initially been restricted to the latter's work. However, after the 1870s he began increasingly to acquire important contemporary works, among them paintings by Corot, Courbet, and Manet, and by the Impressionists Monet, Pissarro, and Renoir. Subsequently, Chocquet became increasingly committed to the work of Paul Cézanne.

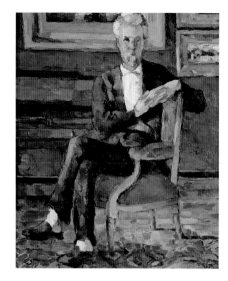

Portrait of Victor Chocquet in an Armchair
1877
Oil on canvas
45.7 x 38.1 cm
Columbus, Columbus Museum of Art

Cézanne depicts his Parisian friend in a classical pose. Calm and concentrated, Chocquet is looking directly at the observer. The subject has added presence through the fact that he fills the canvas.

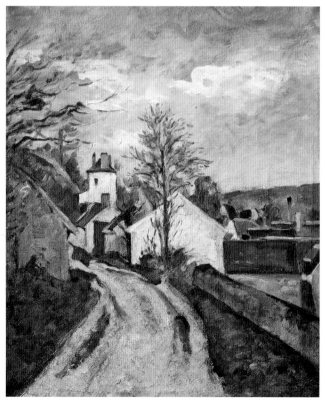

The House of Doctor Gachet in Auvers
ca. 1873
Oil on canvas
46 x 38 cm
Paris, Musée d'Orsay

In the spring of 1872, Doctor Gachet bought a house in Auvers-sur-Oise, close to Pontoise. Towards the end of the year, Cézanne moved with his family from Pontoise to Auvers, where he was to stay for the whole of the following year. He befriended Doctor Gachet, who was the first person to take an interest in his work and who was, in fact, the first person to buy a painting from Cézanne. It was in homage to his first patron that Cézanne portrayed Gachet's house in this painting.

Given this personal connection, the composition of the painting is rather surprising. The house is not set, as one might expect, harmoniously in the Auvers landscape Cézanne found so inspiring. Instead, the observer is led dynamically into the painting along the steeply sloping road. The weather and the autumnal conditions certainly do not give the impression of an idyll. It was presumably the interesting perspective of this view of the buildings that provided the starting point for this "portrait" of his patron's house.

Impressionism

... take hold of the light and throw it immediately onto the canvas.

Claude Monet

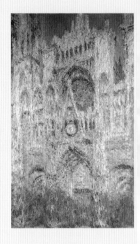

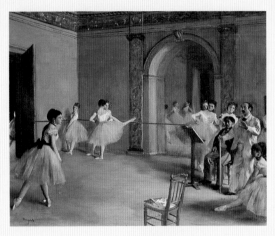

Above:
Edgar Degas
Rehearsal Room of the Opera, Rue Pelletier, 1872
Oil on canvas
32 x 46 cm
Paris, Musée d'Orsay

Below:
Edouard Manet
Monet Working on His Studio Boat
1874
82.5 x 100.5 cm
Munich, Neue Pinakothek

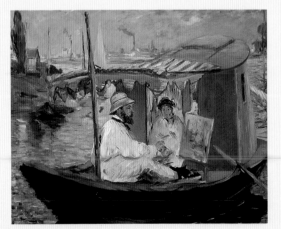

The Impressionists wanted to create instantaneous "impressions" of reality. They were not interested in depicting idyllic images of nature, but in capturing the moment. To do this they had to look very closely at their subjects, and in particular at the way light fell on them. An example of this close study of light can be seen in the paintings of Rouen Cathedral by Claude Monet (1840–1926). Here, with an almost scientific detachment, Monet undertook to record the ever-changing effects of light on the cathedral façade by painting it at different times of day (above right).

The most committed proponent of painting in the open air, Monet even had a small boat converted into a studio to enable him to capture the moods of the river landscape immediately, on the spot. Manet's portrait of *Monet Working on His Studio Boat* is not only a tribute to his younger friend, it is at the same time an artistic manifesto for *plein-air* painting – painting in the open.

Plein-air painting involved more than just a move from the studio to outdoors; for Monet it also entailed a completely new approach to the technique of painting. He insisted that the direct representation of nature was the main objective of painting. But the time-consuming application of carefully graded layers of color mixed in advance – the traditional technique of building up a picture by slow degrees – was not possible with nature, which was constantly changing; even a passing cloud could create a completely new effect. So Monet and the other Impressionists tried to capture the effects of light by painting with rapid brushstrokes and by using bright, unmixed colors; detail gave way to the overall impression. Through this method, which concentrates on recreating the ever-changing impressions of the moment (hence "Impressionism"), it also became possible to express movement.

Left:
Claude Monet
Rouen Cathedral, Early Evening
1892
Oil on canvas
100 x 66 cm
Paris, Musée d'Orsay

Right:
Bathers
1875–1876
Oil on canvas
38.1 x 46 cm
New York, Metropolitan Museum of Art, Joan Whitney Payson Foundation

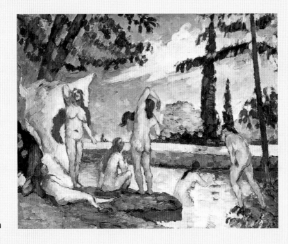

As with photography, which was developing rapidly at this time, the Impressionists attempted to portray snapshots of movement. In paintings such as Renoir's *Dance at the Moulin de la Galette* (below), many of the forms are blurred to imitate the effects of strong light. Moreover, while the figures in the foreground are clearly portrayed, the figures in the background are not depicted individually, but are part of a moving, dancing crowd, just as the eye might really perceive them when looking into the distance, through the sunlight. With this technique, which does not represent objects with clear, individual outlines, the Impressionists were in effect challenging viewers' habits of perception. The intense criticism and mockery the Impressionists received during the early years of the movement arose precisely from their seemingly sketch-like images – images that recorded their subjective perception of the world. But it was not technique alone that alienated the public. The range of themes was also new. The Impressionists quite consciously included in their pictures objects that suggest that the scene depicted is not a formally composed picture but a "slice of everyday life" caught at a specific moment – a development that would have been unthinkable without photography. Thus, in his innumerable scenes of the ballet (opposite, top left), Edgar Degas (1843–1917) often included only parts of the body – a dancing torso or just legs.

Though Cézanne quickly abandoned the attempt to capture such spontaneous impression of nature, many of the innovations of the Impressionists were important in his development. An example of the Impressionist legacy in his painting was his acknowledgement that shadows in a painting are not black, but composed of a multiplicity of different nuances of color.

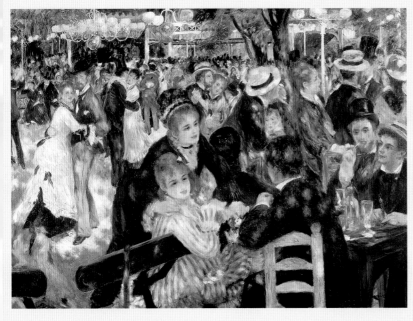

Auguste Renoir
Dance at the Moulin de la Galette, 1876
Oil on canvas
131 x 175 cm
Paris, Musée d'Orsay

Joint exhibitions

From the middle of the 1860s a group of young artists and critics met in the Café Guerbois in the Parisian quarter of Les Batignolles. Besides Manet, who was seen as the leader off the group (which was named after the quarter) it included Zola, Duranty, Fantin-Latour, Degas, Monet, and Burty; Cézanne too joined them from time to time.

As their works were rejected every year by the jury of the Salon, the Batignolles group decided in 1874 to organize their own exhibition of their work. On April 15 the Société Anonyme des Artistes, Peintres, Sculpteurs, Graveurs (Artists, Painters, Sculptors, and Engravers Limited Company) opened its exhibition in the rooms of the photographer Gaspard Félix Nadar, with works by Monet, Pissarro, Renoir, Degas, Sisley and a few others. Cézanne's participation had caused some disagreement after Manet had refused to "compromise himself with Monsieur Cézanne," whom he derogatively described as a "mason who paints with his trowel."

35, Boulevard des Capucines, Studio Nadar
Photograph

The uncomprehending and mocking reactions of the visitors to the exhibition were described later by Zola in his novel *L'Oeuvre* (1886): "The women no longer disguised their laughter with their handkerchiefs, the men extended their bellies the better to laugh out loud. The crowds came to amuse themselves. An infectious merriment spread and became livelier, with splutterings for no cause at all and at nothing in particular. People called to one another to point out a particularly amusing work and witty remarks passed from mouth to mouth."

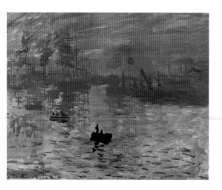

Claude Monet
Impression, Sunrise
1872–1873
Oil on canvas
63 x 68 cm
Paris, Musée Marmottan

The term impressionism was adopted after Monet used the word *impression* in his title.

The House of the Hanged Man

ca. 1873
Oil on canvas
55 x 66 cm
Paris, Musée d'Orsay

This painting – one of the few Cézanne sold at the 1874 exhibition – was generally regarded as the major work of his Impressionist period. Even the normally doubtful Cézanne felt the picture was clearly successful, since he repeatedly allowed it to be shown at exhibitions.

Strongly illuminated surfaces alternate with shadowy areas, bright notes fill the air with light. Although the use of light in the painting shows the influence of Impressionism, the deep shadows of the right half of the painting seem to unbalance the composition. Such large, almost monochrome surfaces are not found in his later landscape paintings.

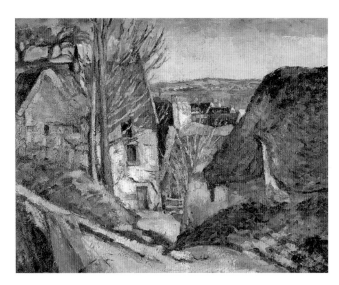

The editor of the satirical political paper *Charivari* wrote an ironic article entitled "The Exhibition of the Impressionists," and unwittingly gave the group of artists their name. The exhibition was a financial failure, so there was no question of a repeat exhibition the following year. By 1886, however, this loosely connected group of artists had organized eight further exhibitions; but Cézanne participated only once more, in 1877.

Cézanne's brief encounter with the Impressionists had introduced him to painting in the open and to the precise observation of nature. But it now became apparent that, for him, a highly structured composition was his major concern, not a spontaneous impression of a scene, as with the Impressionists.

A Modern Olympia

ca. 1873
Oil on canvas
46 x 55.5 cm
Paris, Musée d'Orsay

"This apparition of naked tender pink flesh laid upon an empyrean cloud by some form of demon, like a lascivious vision … this alcove of an artificial paradise has astonished even the bravest among us. With this, Monsieur Cézanne has given us the distinct impression that he is some type of madman." Thus wrote a critic in the journal *L'Artiste* in 1874.

Working from Nature 1878–1885

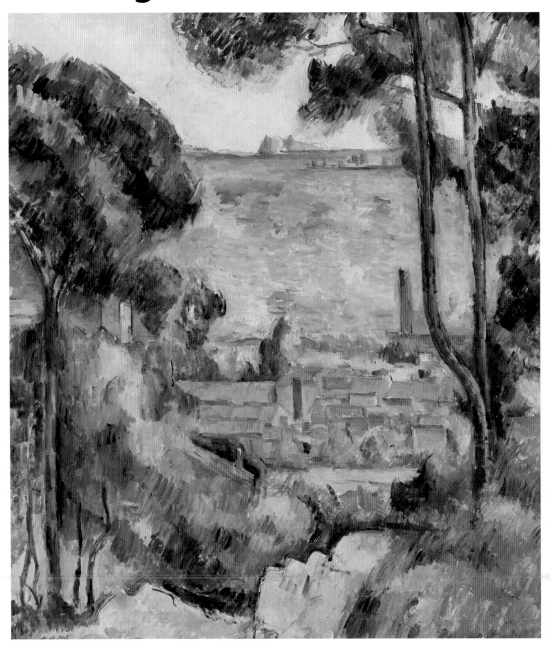

Cézanne spent the following years living alternatively in Aix-en-Provence, L'Estaque, and Paris. From time to time he visited his old friend Zola in Médan. During this period, he almost always lived in the country where, still painting out of doors, he worked hard on developing his technique of landscape painting.

In the summer of 1881 he again visited Pissarro in Pontoise. At this time he also formed a close friendship with Pierre Renoir (1841–1919), with whom he painted around L'Estaque. But most of the time he lived in Aix-en-Provence, where, at the beginning of the 1880s, he painted the first series of paintings of Mont Sainte-Victoire, a theme that was to occupy him for the rest of his life.

In 1882 Cézanne had a picture exhibited at the official Salon for the first time, where he was described as a "pupil of Guillaumin," an Impressionist friend.

Opposite:
View of L'Estaque and the Château d'If (detail), 1883–1885
Oil on canvas
71 x 57.7 cm
Cambridge, Fitzwilliam Museum
Loan from private collection

Right:
Portrait of Paul Cézanne, the Artist's Son
ca. 1883
Pencil on paper
27.2 x 22.9 cm
Vienna, Graphische Sammlung Albertina

Statue of Liberty in front of the World Exhibition Building, Paris 1878

Self-Portrait, ca. 1882

1878 World Exhibition in Paris. Coronation of the Italian King Umberto I.

1879 Foundation of the French Labor Party.

1880 Death of the French author Gustave Flaubert.

1882 Triple Alliance between Austria, Italy, and Germany.

1883 Death of Edouard Manet. Paris-Turkey Orient Express.

1885 Construction of the Brooklyn Bridge.

1878 Cézanne spends the whole year working alternately in Aix-en-Provence and L'Estaque.

1879 Spends the first months of the year in L'Estaque, then return to Paris, and from April to December in Melun, from where he visits Zola in his new house.

1880 Remains in Melun from January to March, then returns to Paris.

1881 Works from May till October with Pissarro again, in Pontoise.

1883–1885 Exhibits a painting at the Salon for the first time. Travels to see Renoir and stays for some time with Zola.

Discovery of a New Landscape

From July 1878 to March 1879, Cézanne worked mainly in the small fishing village of L'Estaque, close to Marseilles, where he had already lived in hiding during the Franco-Prussian War. Over the next few years, he often returned to this village to paint, as he came to realize how much the landscape of his Provençal home was in tune with his artistic objectives.

He wrote to Camille Pissarro: "It's like a playing card here. Red roofs and the blue sea. The sun is so fierce that I feel as though every object was simply a silhouette, not just in black and white but in blue, red, brown, violet. I might be wrong, but it seems to me as though this is the opposite of three-dimensionality."

This flattening of space created by evenly distributed light corresponded

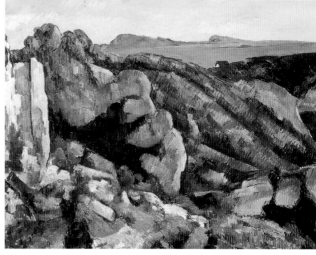

Rocky Landscape near L'Estaque
1879–1882
Oil on canvas
73 x 91 cm
São Paolo, Museu de Arte

With mainly diagonal brushstrokes that cross the surface of the painting

uniformly, like a pattern, Cézanne depicts the rocky, hilly landscape near L'Estaque almost in monochrome – shades of grey and ochre with only light touches of green across them. The massive, rocky

formations are represented by areas of strong light and shade. The prominent, brightly lit stone on the left contrasts with the black shadows of the greenish rocks to the right, which obstruct the view of the background.

The Sea at L'Estaque
1876
Oil on canvas
42 x 59 cm
Zurich, Fondation Rau pour le Tiers-Monde

Cézanne has clearly structured the landscape with skillfully applied color contrasts and the use of a classical picture composition. While the foreground appears to be full of movement through the short

brushstrokes in different directions, the blue sea appears to be a solid mass. On the horizon, islands rise from the sea, their ocher tones echoing the bright ochers of the foreground.

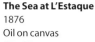

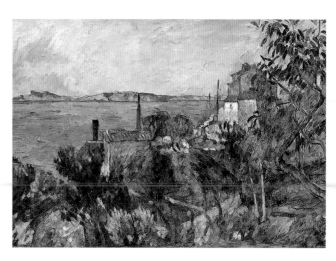

precisely to the form of composition Cézanne was trying to achieve in his painting. And the balanced structure of his compositions was now complemented by a new type of brushstroke. Instead of the dynamic brushstrokes of his early paintings, which brought a sense of movement to the image, he started using regular strokes of color placed close together. Nevertheless, the different areas of the image are clearly separated and spatial depth is often achieved through traditional means, such as placing trees in the foreground to indicate a progressive movement through several spatial levels.

The Bay at L'Estaque
Photograph, ca. 1936

The fact that the southern vegetation with its pines and olive trees hardly ever changed, suited Cézanne very well, for he often spent months painting a landscape.

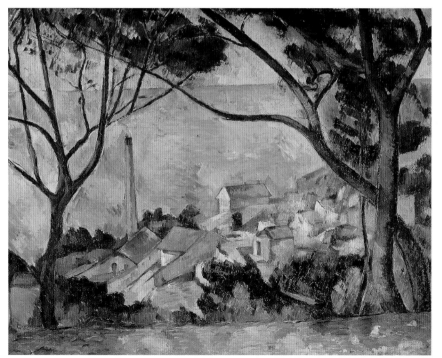

The Sea near L'Estaque
1878–1879
Oil on canvas
73 x 92 cm
Paris, Musée Picasso

From a path running horizontally across the foreground, branches open out onto a view of the village. Red roofs contrast with the green vegetation. The houses are set at different angles and the chimney is effectively used as a vertical element to provide depth to the horizontal fields that form the composition of this view.

Light and Color

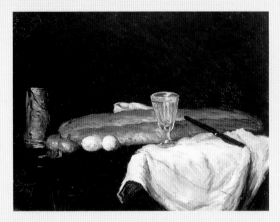

As his style developed, Cézanne's use of color also changed considerably. While his youthful works, with their often dramatic themes, were characterized by powerful, generally dark colors, his palette of colors brightened after his encounter with the Impressionists; in the final stage of his development color assumed a central role in the construction of his compositions.

The dramatic themes Cézanne dealt with during the first ten years of his creative life were often expressed in particularly stark contrast between dark and light. The influence of Spanish still-life painting was also apparent in pictures such as *Still Life with Bread and Eggs* (above). Here the white cloth and the eggs stand out strongly from the background, which is plunged in darkness. Light falls from one direction, casting deep shadows. This painting is still based on the practice of creating illusory effects, which had been the essence of still-life painting since the Renaissance – Cézanne even captures the light reflected in the glass.

As Cézanne, under the influence of Pissarro, began to paint in the open, the darker colors of his palette disappeared and he stopped using black altogether. From time to time he also adopted Pissarro's technique of using small differently colored brushstrokes to render the optical effect created by sunlight (seen from a distance, the colors blend to create an effect far more vibrant that those created by one color). In this way he painted landscapes in the Impressionist manner, flooded with light.

His *Self-Portrait on Rose Background* (below) is also built up by means of color alone, with small brushstrokes of different shades of color being juxtaposed. The face is still modeled using light and shadow, in the traditional fashion. But the coloration of the areas of shadow, round the eyes and cheeks for example, is no longer composed simply of dark tones but of skin tones mixed with red and green; these contrast with the light color of the left side of the brow, which is highlighted with shades of white and green. The background takes up the skin color, an expression of Cézanne's desire to use color to give unity to a composition.

In the landscapes executed from the 1870s onwards, Cézanne avoided depicting any specific light source: the even light ensured that individual elements did not stand

Left:
Still Life with Bread and Eggs, 1865
Oil on canvas
59 x 76 cm
Cincinnati, Cincinnati Art Museum

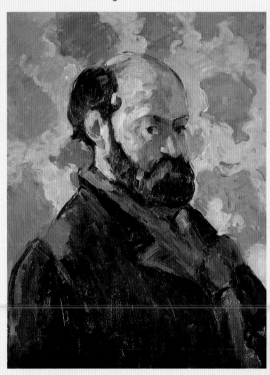

Self-Portrait on Rose Background, ca. 1875
Oil on canvas
66 x 55 cm
Paris, Musée d'Orsay

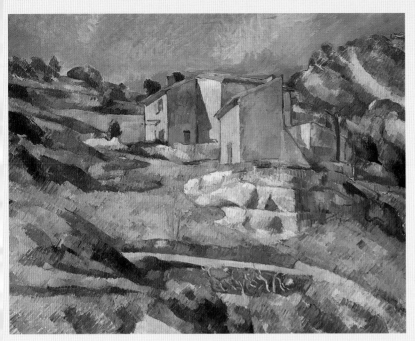

Houses in Provence
1879–1882
Oil on canvas
64.7 x 81.2 cm
Washington, National
Gallery of Art, Mr. and Mrs.
Paul Mellon Collection

out – it was the overall structure of the image that was important. In *Houses in Provence* (above), for example, the luminosity of each element of the picture is finely balanced. This Provençal landscape, flooded with light, is one of the few Cézanne paintings executed in the harsh midday sun. Avoiding strong sunlight, he generally went out to paint in the afternoons, when the light was more diffused and the sun no longer cast deep shadows.

Color was now the most important element of painting for Cézanne. Nevertheless, he used it very differently at different stages of his creative life. In the 1880s and 1890s, he painted highly organized landscapes, in earthy colors, with ochre, green, and blue, that are very different from *Houses in Provence*. In the watercolors of his late period, Cézanne again experimented with color in a completely different manner, now increasingly freeing it from any objective reference. In *Still Life with Apples, Bottle, and Chair Back* (right), Cézanne's use of watercolor gives still life painting, which is extensively represented in his work, a completely new lightness and transparency. In many of his very late watercolors, Cézanne works only with individual patches of color, sometimes vividly juxtaposed on a sheet that is mostly left plain white.

Below:
**Still Life with Apples,
Bottle, and Chair Back**
1902–1906
Watercolor and pencil
on paper
44.5 x 59 cm
London, The Courtauld
Gallery

Harmony in Parallel with Nature

Between 1882 and 1890 Cézanne first began working intensively with the mountain ridge which dominated his native region, Mont Sainte-Victoire, known in English as the "Mountain of Holy Victory." The mountain was supposedly given this name during the first century A.D., after the victory of Marius over the Germanic hordes.

About 20 of Cézanne's works show the Mont Sainte-Victoire from Bellevue farm, southwest of Aix-en-Provence, which had been owned by the artist's sister Rose and her husband Maxime Conil since the 1880s. Cézanne's preoccupation with this subject demonstrates his determination to develop his picture composition as far as possible. He wanted to transform what he saw in nature into a balanced, self-sufficient composition. He was not concerned with simply reproducing a scene, but with developing an independent, harmonious composition from his chosen subjects, creating what he himself called a "harmony in parallel with nature." In these pictures the surface of the image is composed of horizontal areas of color set side by side and interlinking the separate spatial fields. Progressing through one spatial field after another, the

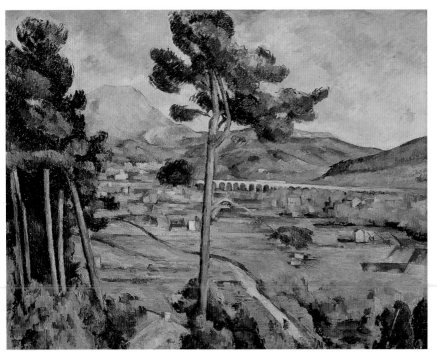

Mont Sainte-Victoire from Bellevue
1882–1885
Oil on canvas
65.5 x 81.7 cm
New York, Metropolitan Museum of Art, H. O. Havemeyer Collection

Quite consciously, Cézanne partially neutralizes the effects of perspective in favor of a unified picture space. The links are subtle: a few of the brushstrokes on the lowest branch of the pine tree are painted over in the color used for the mountain, so that the fore- and background are linked.

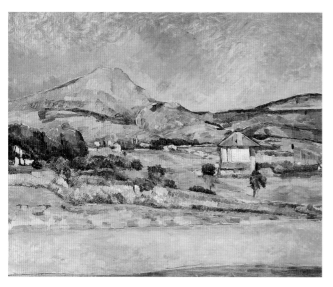

alternating brown and green areas provide a sense of depth.

Isolated diagonals and verticals, in the form of paths, aqueducts, or towering pine trees cut through the compositions. In traditional painting, lines like these were used to produce an effect of perspective. Cézanne rejected this composition device, which had developed in the early Renaissance, because he considered it to be an artificial aid that had no relevance to reality. Certainly he did use elements such as the aqueduct to give the impression of depth, but he incorporated them without regard for the laws of linear perspective: in his paintings perspective is not achieved by lines of sight converging on a common vanishing point.

Mont Sainte-Victoire from the Chemin de Valcros, 1879
Oil on canvas
58 x 72 cm
Moscow, Pushkin Museum

In this view of the mountain from the Chemin de Valcros, the mountain's distinctive silhouette is clearly visible. The angle of view and proportions are the same as in the representation of the massif in the picture entitled *Mont Sainte-Victoire from Bellevue* (opposite). In contrast with the latter, the perspective effect is greatly reduced by the opaque colors and horizontal lines.

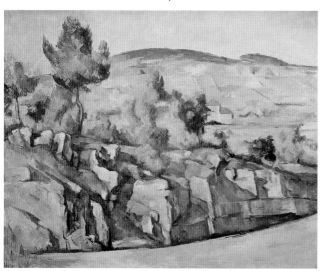

Mountains in Provence
ca. 1890
Oil on canvas
65 x 81 cm
London, The Courtauld Gallery

This painting is one of the earliest of Cézanne's representations of fissured stone formations – a theme which he later worked on intensively in his paintings of the Bibémus quarry. Here Cézanne opposes the contrasting forms of the sharp-edged blocks of stone and the organic, animated green of the trees and flowers in the middle ground. The severity of the vertical rock surfaces is softened by the rounded shapes of the hilltops. The painting conveys a strong impression of the Provençal landscape.

His Own Path

1886–1895

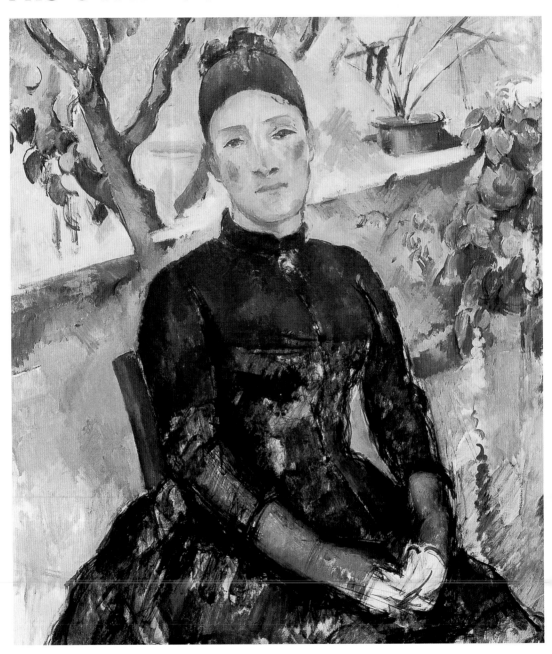

The year 1886 marked an important turning point in Cézanne's life. After years of mutual coolness, the final break with his boyhood friend came after the publication of Zola's novel *L'Oeuvre*, whose central character, an artist, was based on Cézanne; he, Cézanne, never spoke to Zola again. In the same year, his father died, leaving him a considerable legacy. So, at 47 years of age, and for the first time in his life, he had no financial problems, and he gave an allowance to Hortense, whom he had married earlier that year.

He now returned to Aix-en-Provence more and more, and also to the Jas de Bouffan, constantly developing the themes of his paintings. His solitary lifestyle was interrupted only in 1890, when, at his wife's insistence, he traveled to Switzerland for a period of five months, the only trip abroad he ever made.

Friedrich Nietzsche, 1891

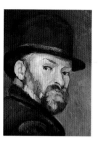

Self-Portrait with Bowler Hat, ca. 1886

1886 Arthur Rimbaud: *Poems*.

1888 Photography becomes widespread through the introduction of cameras with rolls of film. Nietzsche: *Ecce Homo*.

1890 The first motor vehicle in France.

1891–1906 The Dreyfuss Affair in France.

1893 Edvard Munch: *The Scream*

1895 Invention of film; discovery of X-rays.

1886 Cézanne ends his friendship with Zola. On April 28, Cézanne marries Hortense Fiquet. In October his father dies.

1889 Chocquet succeeds in having the *House of the Hanged Man* exhibited at the Paris World Exhibition.

1890 Three of his paintings are exhibited at the exhibition of Les Vingt (The Twenty) in Brussels. He spends spring and summer in Switzerland. Suffers from diabetes.

1891 Cézanne's wife moves to Aix-en-Provence with their son.

1893–1895 Cézanne lives in Aix-en-Provence and Paris.

1895 His subjects include the Bibémus quarry and the Mont Sainte-Victoire.

Opposite:
Portrait of Madame Cézanne in an Armchair
ca. 1890
Oil on canvas
92.4 x 73 cm
New York, The Metropolitan Museum of Art

Right:
Portrait of a Peasant
1890–1892
Pencil on paper
38 x 29 cm
Basel, Öffentliche Kunstsammlung, Kupferstichkabinett

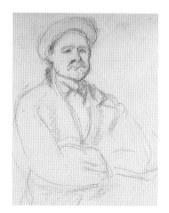

Cézanne's Family

In 1886, after 17 years "on the wrong side of the sheets," Cézanne married Hortense, the mother of his son Paul who was now 14, in Aix-en-Provence.

Until now, Cézanne had kept quiet about both his relationship with Hortense and the existence of a son. In 1878, when his father had opened a letter addressed to Cézanne that mentioned Hortense and "little Paul," there had been a bitter row. Because Cézanne stubbornly denied the connection, his father had drastically cut his allowance, which meant that Cézanne was forced to live with his parents. Meanwhile, Zola looked after Hortense and her son.

The reason for his late decision to marry certainly lay less in Cézanne's affection for Hortense than in the need to legalize the position of the

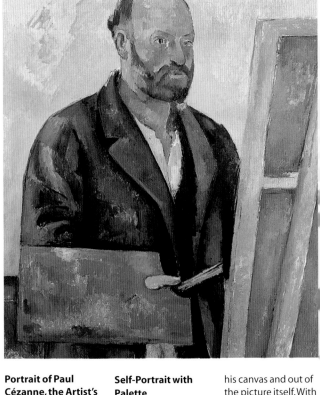

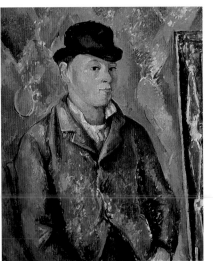

Portrait of Paul Cézanne, the Artist's Son, 1888–1890
Oil on canvas
64.5 x 54
Washington, National Gallery, Chester Dale Collection

Cézanne portrays his son Paul as a young man turning towards us with an open, cheerful gaze, though there is no trace of sentimentality. The static pose is balanced by a frame intruding into the painting at an angle .

Self-Portrait with Palette
ca. 1890
Oil on canvas
92 x 73 cm
Zurich, E.G. Bühle Collection

Among Cézanne's self-portraits, his *Self-Portrait with Palette* is exceptional in that here he depicts himself not just head and shoulders, but as a half-length figure, working at his easel. His eyes focussed elsewhere, he seems to be looking both at

his canvas and out of the picture itself. With its portrayal of the painter's most important tools – the brush, palette, and canvas – this self-portrait is not just a portrayal of the artist; it is also a comment on his role as an artist, constantly interrogating his perceptions of the world in order to turn them into art.

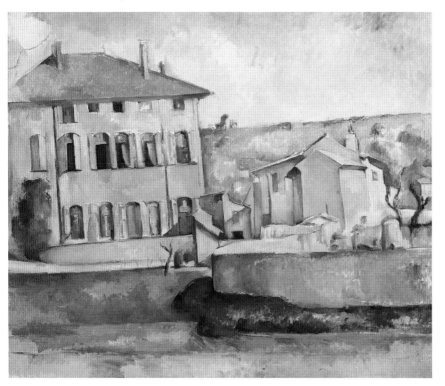

The Jas de Bouffan with its Utility Buildings
1885–1887
Oil on canvas
60.5 x 73.5 cm
Prague, Národni Gallery

Cézanne spent many years of his life at the Jas de Bouffan, his father's property – partly for financial reasons, but also because the quiet of the countryside helped him to work. He depicts this country house in many paintings, selecting different details and viewpoints, or pushing it into the background of a broad landscape. This view is surely the most striking, with the residence to the left and seeming to slope. The other components of the painting are also shown from differing angles, so that there is no unified impression of the Jas de Bouffan.

son, whom he loved dearly. Cézanne had always managed to escape from the close ties of family life. According to his boyhood friend Numa Coste, Cézanne's motto was "Long live the sun and independence." Even after his marriage, he lived with his parents and his sister Marie, while he housed his wife and son in an apartment in Aix-en-Provence. But Hortense preferred life in Paris, and did not in any case get on with Cézanne's family, so that most of the time she lived in the capital with their son.

In a letter to Zola, Numa Coste described the marriage in the following terms: "Cézanne … lives at the Jas de Bouffan with his mother, who has cut off contact with the ball and chain [Hortense], who for her part does not get on with her sisters-in-law, nor the latter with one another. This is why Paul lives here and the wife lives there."

On the other hand, Cézanne always had a close relationship with his son. Till the end of his life he maintained a lively exchange of letters with him, and these provide an important testament to his development, for he often told his son about the everyday problems of his artistic endeavors.

Cézanne and Zola

Paul may have the genius of a great painter, but he will never have the genius to become one. The slightest obstacle makes him despair.

Edouard Manet
Portrait of Emile Zola
1868
Oil on canvas
146 x 114 cm
Paris, Musée d'Orsay, Galerie du Jeu de Paume

The publication of Zola's novel *L'Oeuvre* in 1886 led to a complete break between the boyhood friends. Zola had long planned to write a novel with an artist as the principal character for his monumental cycle of novels *Les Rougon Macquart*. The impulsive painter Claude Lantier is frustrated at the impossibility of completing a painting on which he has been working for years and finally commits suicide in front of his canvas. It was particularly the end of the novel that must have wounded Cézanne most, since the figure of Lantier was unmistakably modeled on him. The short note of thanks on receipt of the book must have been the last sent by Cézanne to his friend. After that, they never saw each other again. But the final break had been preceded by a coolness between the two that had increased over the years. After he had persuaded Cézanne to follow him to Paris after taking his baccalaureate, Zola had initially given active support to his artist friend, who was plagued with self-doubt.

Their relationship began to change, however, with Zola's increasing success. After a year out of work, he had started in the dispatch department at the publishers Hachette and had quickly climbed up the ladder to advertising director. In addition, he

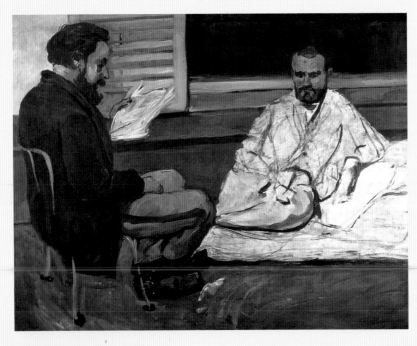

Paul Alexis Reading to Emile Zola
1869–1870
Oil on canvas
131 x 161 cm
São Paolo, Museu de Arte

wrote for newspapers and rapidly made a name for himself as a journalist. He employed Paul Alexis, who had known both Zola and Cézanne in Aix-en-Provence, as his secretary (opposite, below).

Cézanne, on the other hand, was not to have any public recognition for many years to come and was often short of money. It is surprising that Zola, who worked as an art critic and supported many contemporary artists, barely mentioned the work of his boyhood friend in his articles. The obvious conclusion is that even Zola had little real understanding of Cézanne's art. He did indeed consider him to be extraordinarily gifted, but secretly reproached him for wasting his talent when, as frequently happened, his doubts prevented him from completing his work.

Nevertheless, Zola gave his friend financial support whenever he needed it. As we have seen, when Cézanne's father learned of his relationship with Hortense and the existence of their son, Paul, he cut Cézanne's allowance. At this time, Zola already considered Cézanne a failure. Furthermore, Zola's wife, Gabrielle Mély, a former model who had got to know Zola through Cézanne, played a part in the coolness between the two school-friends, for she was set on middle-class recognition and did not welcome any reminders of her impoverished youth.

In 1878, his success made it possible for Zola to buy a summer residence in Médan, in the Paris region. When Cézanne visited him there in 1879, he felt alienated by Zola's grand lifestyle. While Zola led the affluent, middle-class life of a celebrated author, Cézanne behaved provocatively towards those around him; his appearance was down-at-heel and his tone often abusive.

Manet, the artist Zola revered most of all, painted the most convincing and telling portrayal of the urbane and self-confident author (opposite, top right). Art books lie on a table. On the wall, beside Manet's provocative *Olympia* (page 26), hangs a Japanese print, which, together with the

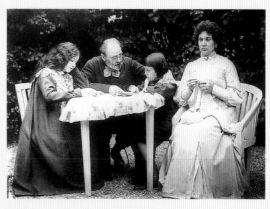

Zola with his family in the garden of his house at Verneuil-sur-Seine

screen on the left, refers to the contemporary fashion for all things Japanese. The sitter is clearly a man of his time.

Below:
Château de Médan
ca. 1880
Oil on canvas
59 x 72 cm
Glasgow, Glasgow City Art Gallery, Burell Collection

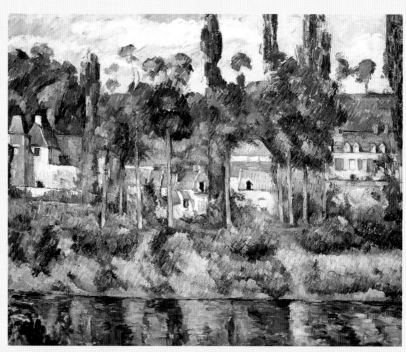

The Perception of Space

For Cézanne, all genres of painting were of equal value. Whether he was painting landscapes, portraits, or still lifes, it was always his aim to create a new reality. He never wanted to produce an illusionistic reproduction of nature: his intention was to make observers aware, through the very technique of the painting, that what they were looking at was an image on a two-dimensional canvas.

Even the genre of still life – the genre traditionally used by artists to create a convincing illusion of reality, often through impressive assortments of sumptuous materials, flowers or fruit – was for Cézanne only one more challenge in his investigation of visual perception. In this investigation the still life had one major advantage over landscape and portraiture: in contrast to nature, with its ceaseless change of mood, and to models, who often could not manage to sit still for very long, a still life arrangement constructed in the studio allowed him to spend days, if not months, studying the

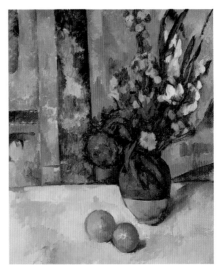

Still Life with Vase of Flowers and Apples
1889–1890
Oil on canvas
55 x 47 cm
Switzerland, private collection

His slow method of working was undoubtedly the reason Cézanne very seldom used flowers in still lifes. As flowers soon fade, they changed too quickly for Cézanne, who often spent days just observing his subjects.

Still Life with Apples and Oranges
ca. 1895–1900
65 x 81 cm
Paris, Musée d'Orsay

Compared with other still lifes by Cézanne, this picture seems overburdened. There is no empty space; two different materials occupy the background to the picture, while the white tablecloth dominates the foreground. The rug with the rust-brown rectangles in the left half of the painting figures in many of the late still lifes. As ever with Cézanne, the color references have been thought through into the smallest detail. To give just one example, the small green fruit half-hidden by the tablecloth, on the left by the plate, picks up the green of the sofa upholstery. Correspondences like this produce a composition that is harmonious through and through.

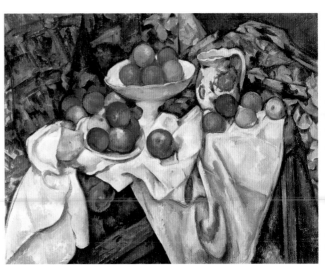

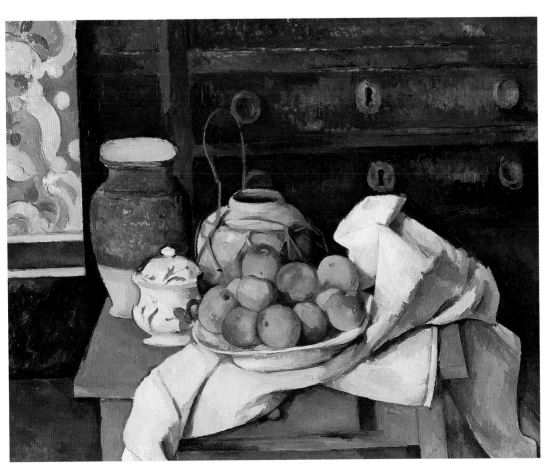

same collection of objects. This meant he could experiment with what fascinated him above all else – representing an object from various viewpoints.

Still Life with Dresser (detail)
1883–1887
Oil on canvas
65.5 x 81 cm
Cambridge, Harvard University, Fogg Art Museum

Cézanne indicates various spatial planes by means of the different effects of depth produced by color. Optically, the orange-red apples push themselves forward, while the dresser appears to be in the background because it is brown. Table, dresser, and floor provide a framework for the space in which the still life is laid out. But these objects are not depicted in the correct perspective. So the table top seems to break up under the white cloth and the dresser also escapes into the depths to the left, while the right side seems to be portrayed from the front. And while many of the objects in the still life appear to be observed from above, others are represented as being at eye-level for the observer.

Still Life with Basket of Fruit

I should like to amaze Paris with an apple.

Paul Cézanne

Cézanne's still lifes are restricted to a few simple objects he used time and again. It is precisely because the contents of a still life can be studied in this way that the genre was particularly well suited to Cézanne's exploration of perception. In his first still lifes Cézanne concentrated entirely on the objects arranged on a table, without defining the surrounding space. In innumerable studies of apples he concentrated on how an apple could be modeled using color alone, without resorting to traditional means such as outlines or shading, techniques he rejected as "illusionist tricks." He wanted to paint the apple just as he saw, that is, as a collection of various color tones.

After he had "conquered" the apple, Cézanne concentrated on the arrangement of the still life in space. In *Still Life with*

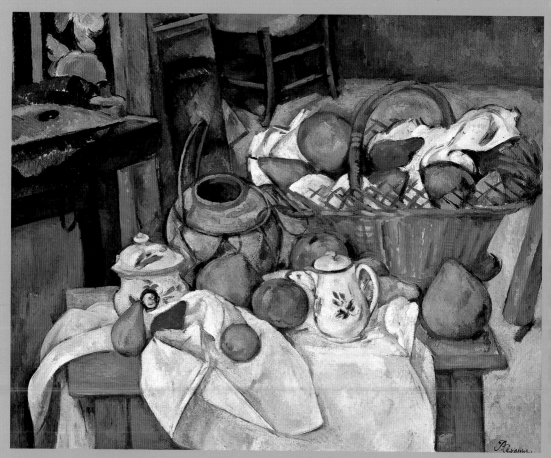

large pot near the basket of fruit – and the ginger jar in *Still Life with Ginger Jar, Sugar Bowl, and Apples* (below) – we seem to be seeing it both from above and from the front. Cézanne, who was well acquainted with the classical rules of perspective, disregarded them quite consciously because he felt that a single unified viewpoint is never adequate for the true perception of an object. He rejected conventional perspective, with its vanishing point based on one single viewpoint, because it created an image that is not true to our experience.

Nevertheless, he did not want to abandon the impression of spatial depth completely; rather, he used new methods to suggest it, notably color and modified perspective. Color values in particular form a crucial part of his principles of composition; he does not use them simply to reproduce the actual appearance of an object. In *Still Life with Basket of Fruit,*

the excessive proportions of the pear in the foreground right relates it to the equally large green pear in front of the blue pot and also to the red and green apple to the left, in front of the fruit basket. The three round green patches of color pick up the small shapes on the table and simultaneously form a striking counterbalance to the dominating shape of the fruit basket.

By discarding traditional means of representation, Cézanne was taking into account the fact that any perception of an object involves a knowledge of its full volume: this understanding of an object as a totality allows us to "complete" a partial view of it. In Cézanne's eyes, things achieve their true form only when this knowledge is incorporated into a painting.

Opposite:
Still Life with Basket of Fruit
1888–1890
Oil on canvas
65 x 80 cm
Paris, Musée d'Orsay

Above:
Still Life with Basket of Fruit (detail)
1888–1890

Basket of Fruit (opposite), the table, dresser, chair, and floor provide a spatial reference for the still life. But these objects are not represented in "correct" perspective: the conventional lines of perspective are distorted.

Just as in *Still Life with Dresser* (page 55), the front edge of the table appears to break at the point where it is hidden by the cloth, and the chair leg on the right of the painting is not depicted in accordance with linear perspective either. The viewpoints change just as much with the objects lying on the table. Some are seen from above, others from the

side. Even the fruit basket is depicted from several different viewpoints: while in the lower part of the basket the weave is shown from the front, the fruit seems to be viewed from above.

In his still lifes, Cézanne often used this method of portraying the same object from two angles. With the

Still Life with Ginger Jar, Sugar Bowl, and Apples
1893–1894
Oil on canvas
65.5 x 81.5 cm
Private collection,
Permanent Loan, Zurich
Kunsthaus

Peasants and Card Players

After landscapes and still lifes, portraits are the other most important group of paintings in Cézanne's work. In addition to countless self-portraits, Cézanne also painted many portraits of his wife Hortense, who was clearly his most patient model – Cézanne insisted that his models kept absolutely still for the whole sitting. By the beginning of the 1890s, however, as his wife was no longer prepared to sit so frequently and for such long periods, Cézanne started looking for models among the peasants and day laborers who worked on the rented fields at the Jas de Bouffan, whom he could pay to sit still.

As with the previous figure paintings, the portrait subjects were never portrayed as individuals; Cézanne was not in the least interested in the details of their lives. In Cézanne's work, we search in vain for any expression of the social criticism expressed in the painting and literature of many of his contemporaries.

Among Cézanne's major works of the 1890s is a series of card players on which he worked for several years. Altogether five versions of this subject have survived, with Cézanne reducing the number of sitters from the original five, then four, to two in the last three paintings. There are also many pencil, watercolor, and oil studies on this theme; these reveal that he did not work directly from such a scene, but created a number of individual figures that he then combined to form a single composition.

Although the position of the card players appears very static because

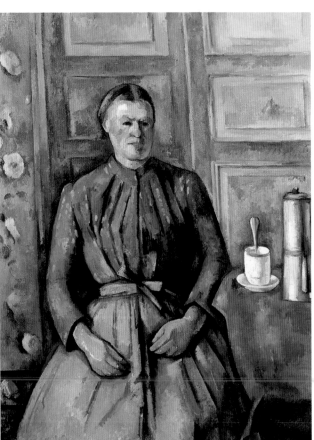

Woman with Coffee Pot
ca. 1895
Oil on canvas
130 x 70 cm
Paris, Musée d'Orsay

The woman sits stifly upright in her chair. Echoing this stance is the coffee pot, the cup, and the vertical spoon; the only horizontal counterbalance comes from the background paneling.

The Card Players

1893–1896
Oil on canvas
47.5 x 57 cm
Paris, Musée d'Orsay

Although they depict scenes from everyday life, Cézanne's paintings of card players can hardly be described as genre paintings. For Cézanne removes the anecdotal content from this theme and concentrates on transforming the composition into a representation of figures in space. The images are constructed in accordance with strict laws of color and shape that leave far behind them the everyday aspects of the scenes represented. The painting is restricted to earthy brown and gray tones. The view through the window into the dark indicates the late hour. Spots of light on the clothing of the players, the table, and the bottle are reflections of the artificial lighting. The posture of the two card players is subordinate to the overall composition. The diagonals formed by their arms meet on the table; the vanishing point of the lines formed by the sides of the table is the top of the bottle.

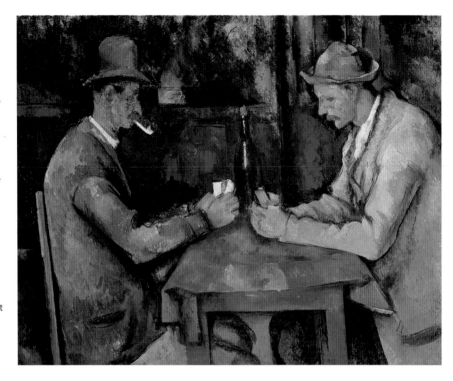

of this obviously artificial construction, the paintings have a strong inner energy that derives largely from the concentrated stillness of the figures. Even when depicting such a familiar scene, Cézanne was able to subsume it into a concept of painting that sought to freeze moments in time, to isolate them from an ever-changing present.

The Card Players

1890–1892
Oil on canvas
65 x 81 cm
New York, Metropolitan Museum of Art

The prevailing blue tones lend a slightly unreal air to this everyday scene in which men play a quiet game of *belotte*.

The players are depicted as motionless, with their gaze fixed on their cards. The strongly contrasting use of orange stresses the concentration of the players. The deep folds in the clothing of the player on the right are continued in those of the curtain.

Mardi Gras and Harlequin

Sometimes it takes a very long time to capture and define a model.

Paul Cézanne

Cézanne started to plan the composition of the Harlequin painting during a fairly long stay in Paris. As his son later recounted, he and his friend Louis Guillaume were the models for *Mardi Gras* (opposite), which was painted in a newly rented studio in rue Val-de-Grace during the winter of 1888. Cézanne painted the two friends as Harlequin and Pierrot. Adopted from the popular Italian theater of *commedia dell'arte*, the figures of Harlequin and Pierrot, with their distinctive costumes, had been painted by many artists since first depicted in French Rococo painting, notably by Antoine Watteau (1684–1721).

For over two years Cézanne worked tirelessly on the details of the composition. In many drawings, watercolors, and oil sketches he worked on the faces of the two young

Harlequin
1888–1890
Oil on canvas
100 x 65 cm
Washington, National Gallery of Art, Mr. and Mrs. Paul Mellon Collection

men and the figure of Harlequin. Whether these preceded the large *Mardi Gras* composition or not can no longer be determined with any certainty.

In *Mardi Gras*, Harlequin and Pierrot are just about to step on to the stage, indicated by a curtain going up in the background. While Harlequin is striding forwards, upright, Pierrot is a pace behind and seems to be just giving his companion something, or taking something from him. The floor runs back in a distorted perspective, so that Harlequin needs oversized feet for support. The costumes of the two figures – the traditional diamond pattern for Harlequin and the baggy

Study for Mardi Gras
1888
Chalk and pencil on paper
24.5 x 30.6 cm
Paris, Musée du Louvre

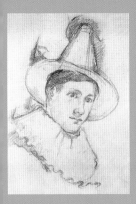

Paul Guillaume in Pierrot Costume, 1896–1897
31.4 x 24.3 cm
Pencil on paper
Basel, Öffentliche Kunstsammlung, Kupferstichkabinett

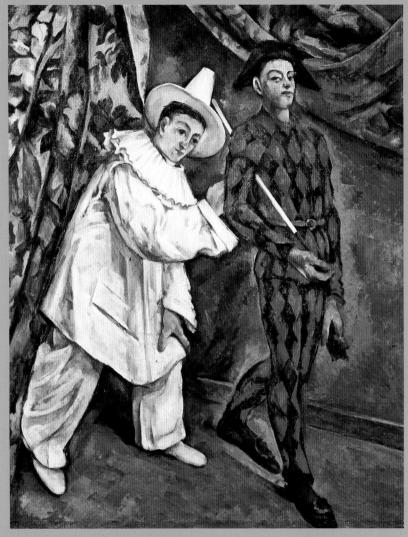

Mardi Gras
1888
Oil on canvas
102 x 81 cm
Moscow, Pushkin Museum

costume with ruff for Pierrot – provide a sharp color contrast. The hard white of the Pierrot costume is skillfully tied into the overall composition, since almost all the color tones surrounding it are reflected again in the white.

Although the figures – and here *Mardi Gras* is an exception in Cézanne's work – are portrayed in movement, they have a stiff and unnatural appearance, and there is no trace of any of the lightheartedness or humor usually associated with this theme. This is all the more surprising as drawings from the same period show very lively carnival scenes.

Through the serious and self-confident gaze of Harlequin, Cézanne very consciously establishes a distance between the observer and the figures in the painting. The strong contrast between the costumes of the two figures, the seriousness of their expression, and their stiff but resolute stance, which shows them upright when they should (given the slop of the floor) be leaning forwards, combine to produce a picture of great energy.

While he was still alive, Cézanne failed to receive wide public recognition of his achievement. And it was only during the final decade of his life that his work began to win far more appreciative attention from critics.

Articles had always appeared in the press attacking his art vehemently, but now a few voices could be heard praising his work in the highest terms. His first one-man exhibition was in 1895, at the Paris gallery owned by Ambroise Vollard. It played a major role in his reappraisal. This was the first opportunity for many art connoisseurs to see a comprehensive selection of works by this reclusive artist, who lived not in Paris, at the center of the art world, but in the relative obscurity of Aix-en-Provence. Even though his earliest supporters were mainly other artists, the considerable prices his paintings suddenly made at auction clearly show that a wider public was beginning, at long last, to accept his work.

Opposite:
Girl with Doll (detail)
1902–1904
Oil on canvas
73 x 60 cm
Berlin, Sammlung Berggruen, Staatliche Museen zu Berlin,
Preussischer Kulturbesitz

Right:
Standing Putto
ca. 1890
Pencil on paper
49.7 x 31.9 cm
London, The British Museum,
Department of Prints and Drawings

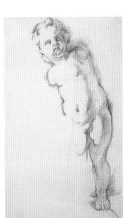

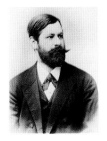

Sigmund Freud, ca. 1895

Cézanne, ca. 1895

1895 France conquers Madagascar. Sigmund Freud lays the foundation of psychoanalysis.

1896 Beginning of the Art Nouveau movement. The first Olympic Games of modern times is held in Athens.

1898 Marie and Pierre Curie discover radium and plutonium.

1900 Formation of the English Labor Party.

1901 Rudolf Steiner: *Anthroposophy.* Death of Queen Victoria. Discovery of the Ice Age cave paintings in southern France.

1895 Cézanne sends 150 paintings to Vollard for his first one-man exhibition.

1896 Cézanne paints at the Bibémus quarry. Two of his paintings are donated to the Luxembourg Museum.

1897 His mother dies in October.

1899 The Jas de Bouffan is sold. Cézanne exhibits at the Salon des Indépendants. Second exhibition at Vollard's gallery in Paris.

1900 In Berlin, the Galerie Cassirer holds the first Cézanne exhibition in Germany.

1901 Cézanne buys a piece of land above Aix-en-Provence, to build a studio. He exhibits once more at the Salon des Indépendants.

The First Major Exhibition

The myth of the recluse from Aix-en-Provence, which had already grown during his lifetime, arose not least from the fact that Cézanne's work was almost never to be seen. His work had not been exhibited in Paris since 1877, when Cézanne had participated for the last time in an Impressionist exhibition.

It was only in the small shop of Julien Tanguy, the paint seller who often accepted his customers' work in payment for materials, that the initiated could see Cézanne's paintings. By then Cézanne had long been considered a major artist by his painter friends, principally Pissarro, Renoir, and Monet. It was also Renoir and Pissarro who persuaded the young gallery owner Ambroise Vollard to hold a special exhibition of Cézanne's work in his gallery in the rue Lafitte.

Vollard made contact with the painter through the latter's son, Paul, who persuaded his father to select

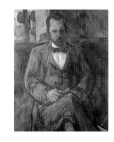

Portrait of Ambroise Vollard
1899
Oil on canvas
100 x 82 cm
Paris, Musée du Petit Palais

As a law student, Ambroise Vollard had seen Cézanne's first paintings in Père Tanguy's little paint shop in 1892. The following year he opened his gallery in the rue Lafitte in Paris. Cézanne gives this portrait of his patron a calm and serious air through the use of a very formal composition. The dark coloration, and the fact that he is apparently seen from a certain distance, strengthen this effect. His posture also indicates that the sitter himself is keeping a certain distance from the observer.

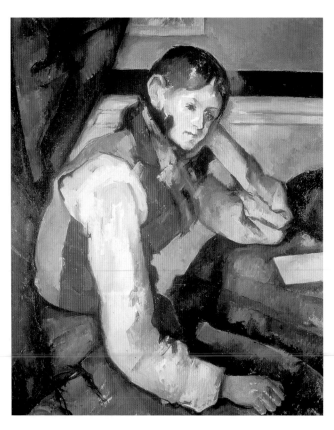

Boy with Red Waistcoat
1888–1890
Oil on canvas
79.5 x 64 cm
Zurich, E.G. Bührle Collection

Cézanne painted several portraits of the Italian model Michaelangelo di Rosa during a fairly long period in Paris. The position of the thoughtful, self-absorbed figure, his head leaning on his hand, turns the work into an unusually penetrating personality study. The strongly contrasting colors give a very lively effect to the scene in spite of the restful pose of the young man and the melancholy mood. The painting is one of Cézanne's best known works.

150 works to form a retrospective of his work. However, Cézanne himself, now 56, did not travel to Paris for his first one-man exhibition, which took place in November and December 1895. It was a great success with the press and fellow-artists. Pissarro reported that Degas and Renoir had had a disagreement about a drawing by Cézanne, which they had both wanted to buy and which finally had to be decided by lot.

The Blue Vase
1889–1890
Oil on canvas
62 x 51 cm
Paris, Musée d'Orsay

In this rare example of a still life with flowers, Cézanne concentrates the color contrasts round the vase of flowers, where he works with powerful shades of blue, red, and green; the apples to the side appear to be merely an embellishment.

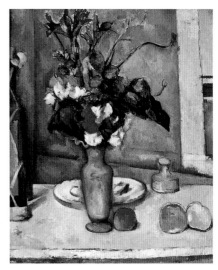

He is a great seeker after truth, fiery and naïve, austere and subtle. He will get to the Louvre.

The art critic Gustave Geffroy in *Le Journal*

Still Life with Curtain
ca. 1899
54.7 x 74 cm
St. Petersburg, Hermitage

The unfinished area in the bottom right corner plays an important compositional role in this otherwise very thoroughly worked picture. The tablecloth gives the picture an impression of spontaneity and also enhances the apparent solidity of the other elements of the painting.

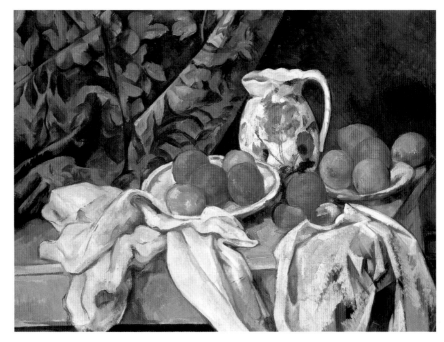

Cézanne in Vogue

In spite of the admiration fellow artists had long had for Cézanne, he was generally unknown until well into the 1890s. Nevertheless, he had already been acknowledged abroad even before his 1895 exhibition at Vollard's gallery, which first introduced his work to a wider public. In 1889 he had been invited to take part in the "Les Vingt" (The Twenty) joint exhibition in Brussels. Also, his paintings had been shown at the 1889 and 1900 World Exhibitions in Paris, though they had not excited much interest.

After the initial success of the three exhibitions organized by Vollard – after the first in 1895 there were two more, in 1898 and 1899 – he did in fact enjoy great acclaim during the final years of his life. A little surprised, Pissarro observed this sudden recognition of Cézanne by noting that since the turn of the

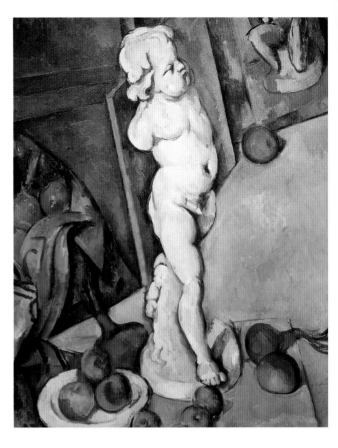

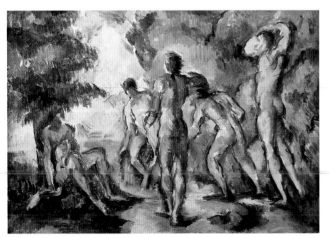

Five Bathers
1898–1900
Oil on canvas
79.5 x 64.5 cm
Basel, Galerie Beyeler

This painting was executed while Cézanne was struggling with the grouping of figures in *The Bathers* (pages 82–85). Of particular interest are the contrasts between movement and repose, light and shade.

Still Life with Putto
ca. 1895
Oil on paper
70 x 57 cm
London, University of London, Courtauld Institute Galleries

The rounded forms of the onions, the apples, and the putto are in stark contrast with the angular canvases and the flat surfaces of the sloping floor.

century the recluse from Aix-en-Provence was "very much in vogue," a fact which, he wrote to his son Lucien, "is quite amazing."

Although weakened by diabetes and age-related bouts of depression, Cézanne nevertheless enjoyed having an increasing number of admirers. In Paris, and in his hometown of Aix-en-Provence, where his paintings were shown at the exhibitions of the newly founded fine arts society, Cézanne finally found the recognition he had had to wait for all his life.

In 1900, the Berlin National Gallery became the first museum to acquire a Cézanne. In the same year the renowned Berlin gallery owner Paul Cassirer held a one-man exhibition of Cézanne's work. None of the paintings was sold, but this did not prevent Cassirer from holding a second Cézanne exhibition at his gallery in 1904. Paintings by Cézanne were now seen more frequently in Paris, too. After 1899, Cézanne took part almost every year in the Salon des Indépendants. And at the Salon d'Automne in 1904, 33 works by Cézanne were exhibited together in a separate room – which, given the rejection of his early work, was an amazing testament to his success.

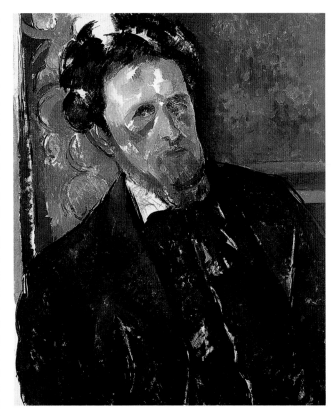

Portrait of Joachim Gasquet
1896
Oil on canvas
65 x 54 cm
Prague, Národni Gallery

The Symbolist poet Joachim Gasquet, 23 when this portrait was painted, was the son of a former school friend of Cézanne's. He admired Cézanne, with whom he formed a very close friendship for a time. Gasquet later recounted that he had only sat five or six times as a model for his portrait. "I thought he had given up the painting. Later I learned that he had spent about 60 sessions on it, that he had always been thinking about his work when he looked at me with his searching gaze during our conversations, and that he worked on it when I had left."

Among Cézanne's late portraits, that of Gasquet has a special place because of the lightness of the brush strokes. Also, Cézanne's usual impartial attitude towards his subjects seems to be absent here, with countless reflections of light relieving the severe formality typical of Cézanne's other portraits.

Cézanne and the Art Market

**Portrait of Madame
Cézanne in a Yellow Chair**
1888–1890
Oil on canvas
81 x 65 cm
Private collection

During Cézanne's lifetime, his paintings were not exhibited very often. In the period between the Impressionists' exhibition in the mid-1870s and Cézanne's first one-man exhibition at Vollard's gallery in 1895, his paintings were not exhibited even once. Very few artists and art lovers were aware that in his shop in Montmartre, the paint seller Père Tanguy kept a few of Cézanne's works, which he showed to the curious, and sometimes even sold. When Vollard exhibited Cézanne's work in 1895, 1898, and 1899, the paintings achieved surprisingly high prices, in spite of the mocking articles in the newspapers. Vollard had bought Cézanne's paintings through the artist's son, Paul, who received ten percent agent's commission both from Vollard and from his father.

From 1900, recognition for the artist grew year by year and increasingly high prices were paid for his paintings. In March 1903, when, on the death of his boyhood friend Zola, the latter's art collection was auctioned, an early Cézanne painting, *The Abduction,*

Highest prices paid for Cézanne paintings

The Large Apples
Auction, 11.05.1993
US$ 26,000,000

Portrait of Madame Cézanne in a Yellow Armchair
Auction, 12.05.1997
US$ 21,000,000

Apples and Table Cloth
Auction, 27.11.1989
US$ 15,600,000

Roofs of L'Estaque
Auction, 12.05.1997
US$ 11,500,000

Château Noir
Auction, 19.11.1998
US$ 10,500,000

Harlequin
Auction, 12.11.1988
US$ 7,480,000

The Bibémus Quarry
Auction, 15.11.1989
US$ 6,000,000

A Modern Olympia
Auction, 13.11.1997
US$ 5,400,000

Bathers
Auction, 29.06.1992
US$ 1,200,000

Château Noir
ca. 1904
Oil on canvas
69.2 x 82.7 cm
Private collection

reached a record price of 4,200 French francs – whereas a painting by Manet reached only 2,800 francs and paintings by Pissarro reached between 500 and 920 francs.

In 1904 two major collectors began to take an interest in Cézanne's work: the brother and sister Leo and Gertrude Stein, in whose apartment in the rue de Fleurus Picasso had seen the portrait of Hortense, *Portrait of Madame Cézanne in a Yellow Armchair*, which was to have a significant impact on his own *Portrait of Gertrude Stein*. Cézanne also regularly participated in the Paris Salon d'Automne after 1904.

Leo Stein recounted how quickly public opinion about Cézanne changed during these years: "Earlier, few people recognized Cézanne's significance; he was now becoming more significant to everyone. At the 1905 autumn salon people had gone into fits of hysterical laughter at his paintings; in 1906 they looked at them respectfully, and in 1907 they were in awe. Cézanne was the man of the moment."

After Cézanne's death, his wife and son sold almost the whole artistic legacy within a very short time. This may have been because they considered the high prices to be a short-term fashion and wanted to dispose of the paintings while they were still selling well. In March 1907, Cézanne's son sold 187 watercolors and 12 paintings to Vollard and the Bernheim-Jeune brothers for a total of 110,000 francs. Shortly before this, the two galleries had already acquired 17 paintings for 165,000 francs. The Bernheim brothers showed their holdings at an exhibition where Cézanne's paintings sold for 1,000 francs each.

There had long been an interest in Cézanne in other countries, too. After the first major exhibition outside France, at Cassirer's gallery in Berlin in 1900, Alfred Stieglitz exhibited Cézanne's watercolors in his New York gallery in March 1911. Only a few years after his death, Cézanne's work enjoyed enormously high prices and even today are among the most highly priced works in the art market.

Bathers
1902–1906
Oil on canvas
29.2 x 23.5 cm
Private collection

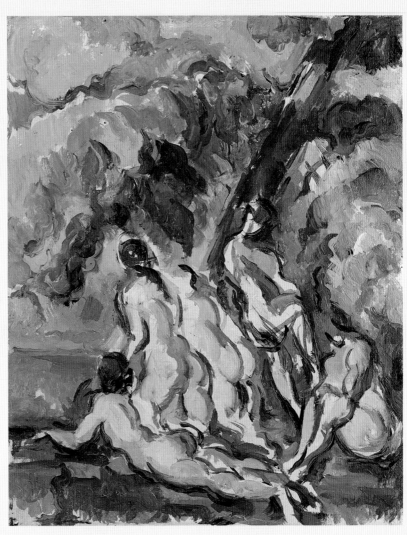

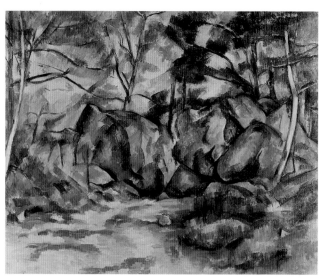

The Undergrowth
ca. 1893
Oil on canvas
51 x 61 cm
Zurich, Kunsthaus

In this portrayal of a woodland path, it is clear that at this time Cézanne was concentrating particularly on volume and perspective. Flat areas such as the path leading into the middle ground are contrasted with physically modeled features such as the boulders to the right. Strong contrasts – for example the green of the pines and the light blue of the sky shining through them – contribute to an impression of a small, confined space that is cut off from the (unseen) surrounding landscape. The effect of perspective is cancelled by the strong outlines of the branches, which appear to spread themselves across the painting like a net.

On the Road to Abstraction

During the second half of the 1890s, in his efforts to create a balance between the different elements of an image, Cézanne increasingly reduced the individual components of his landscapes to simple shapes. Moreover, he reduced the contrast between the natural forms portrayed by the evenness of technique and brush strokes. Although he had not quite separated himself from the traditional representation of identifiable objects, his late paintings are works that the founders of abstract painting in the 20th century continually referred to.

In the 1890s, Cézanne was mainly painting to the east of Aix-en-Provence, in the vicinity of the Bibémus quarry and the so-called

The Bibémus Quarry
ca. 1895
65 x 80 cm
Essen, Museum Folkwang

As in very few other paintings, Cézanne succeeded in The *Bibémus Quarry* to establish a parallel between the subject of the painting and his own characteristic technique. The structure of the stone is strongly suggested by the strong contours and geometric forms with which Cézanne was working at this period.

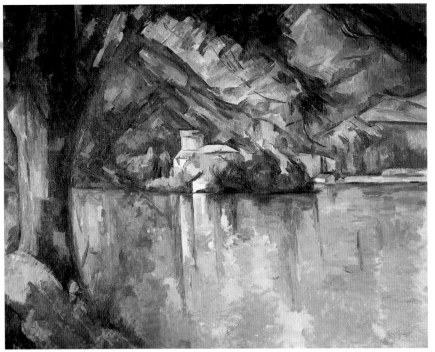

Lac d'Annecy
1896
Oil on canvas
65 x 81 cm
London, Courtauld
Institute Galleries

In the summer of 1896, Cézanne and his family traveled to Talloires, on the Lac d'Annecy in Switzerland. Only this painting was executed there. Almost romantic in effect, with the rays of sun spreading across the surface of the water, it is in complete contrast with the severe landscapes he painted in earthy colors. In fact, for Cézanne the landscape of the mountain regions seemed too soft, and more suitable, in his opinion, for "drawing exercises by young Englishwomen."

Château Noir (Black House), which owed its name to its builder, a coal merchant. Cézanne's paintings from this period are dominated by views into the thick undergrowth close to this country house, and of the shattered rocks of the old quarry. The contrast between the geometric shapes resulting from human intervention and the soft lines created by nature over the centuries inspired Cézanne to paint the quarry many times.

Fine, slightly blurred black and dark blue brush strokes depict the individual surfaces of the rock formation's outcrops and clefts. Small areas of thinly applied color enliven individual surfaces and help to create a scene flooded with sunlight. In spite of the three-dimensional modeling of individual areas of the rocks, Cézanne managed at the same time to reduce the effect of depth in the painting and to stress the flatness by using uniform, relatively short brushstrokes. The transitions are partially blurred and there is no modeling even for the trees, which seem to function simply as intervals of color meant to relieve the dominating ochres of the rocks.

A New Studio

After his mother's death in 1897, Cézanne's brothers and sisters sold the Jas de Bouffan in order to divide the legacy between them. As a result, Cézanne, who had spent almost a lifetime living and working at the Jas de Bouffan, spent a comparatively long period with his wife and son in Paris in 1898 and 1899, though this was for the last time.

In rue Boulegnon, in the center of Aix-en-Provence, he rented an apartment with a small studio and employed a housekeeper, Mme. Brémond. He also rented small sheds and rooms in the countryside round Aix-en-Provence in order to store his materials close to any subject he happened to be working on. He would have gladly bought the Château Noir, one of his most frequent subjects during the final years and where he had also rented a small room, but the owner rejected his offer.

The studio building on the Chemin des Lauves
Photographs

On a hill not far from Aix-en-Provence, Cézanne's new studio building offered an ideal starting point for work "with the subject." Today visitors can still get an impression of the ideal light conditions in the studio, and see some of Cézanne's favorite landscape subjects from the windows.

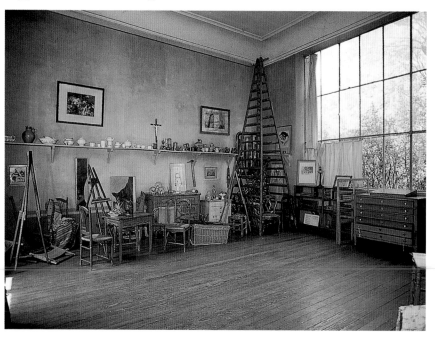

In November 1901, Cézanne finally acquired a piece of land to the north of Aix-en-Provence, on the as yet undeveloped hill of Les Lauves. Here he had a simple building erected, with a five-meter (16-feet) high well-lit studio (opposite); he began working there in September 1902. It was the first time in his life that he had access to a large studio. Nevertheless, he continued living in his apartment in town and most mornings would set out very early for the Chemin des Lauves, returning at midday and then going back to his studio to paint. Friends who visited him during this period later reported on the disorder in Cézanne's studio, where half-empty tubes of paint and dried-up brushes were lying about, and where objects for his still lifes covered the tables.

During the final years of his life, the artist often withdrew to the shady terrace at his studio, where, among other things, he executed the series of portraits of his gardener Vallier. After Cézanne's death the studio passed through several hands and was finally acquired by a committed American charity that in 1954 made a gift of it to the town of Aix-en-Provence, on condition it was opened to the public.

Cézanne's Studio in Les Lauves
Photograph

Most of the well-known objects for Cézanne's still lifes, which appeared repeatedly in his paintings, have been preserved in the studio.

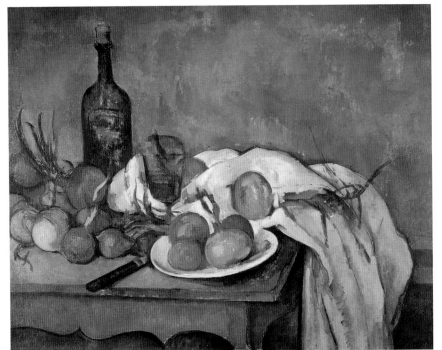

Still Life with Onions
1896–1898
Oil on canvas
66 x 82 cm
Paris, Musée d'Orsay

Looking as though its objects had been selected by chance, *Still Life with Onions* is more striking than many of Cézanne's other still lifes. While the group of objects to the left is cut off sharply by the edge of the painting, there is enough space on the right for the folds of the cloth, which falls generously over the table edge. The wide, plain background contrasts strongly with the rich detail of the objects laid out on the table.

Late Works

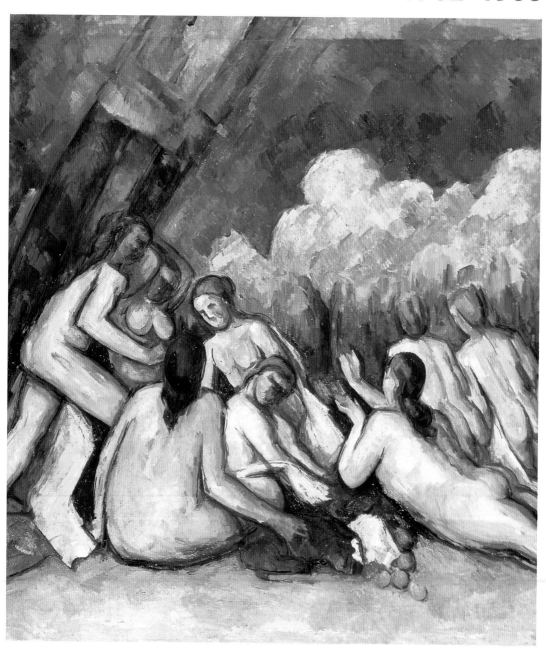

Once Cézanne had found a permanent place of work in his newly built studio at Les Lauves, he was able to concentrate exclusively on realizing his aims as an artist. More than ever before he restricted himself to a few themes, which were to become the best-known of his whole output: landscapes featuring Mont Sainte-Victoire, and his variations on groups of bathers. Although in the meanwhile Cézanne's fame had spread beyond the borders of France, he lived a retiring life and had little contact with friends. He traveled only once more to Paris, for the Salon d'Automne of 1904, when he visited Hortense. He died on October 22, 1906, in Aix-en-Provence.

First airship over London, 1902

Cézanne in the year 1904

1902 Lenin: *What Is To Be Done?* Death of Emile Zola.

1903 Death of Camille Pissarro.

1904 Foundation of the World Association for Women's Suffrage in London. *Madame Butterfly* by Giacomo Puccini.

1904 Major Matisse exhibition in Paris. Invention of offset printing. The first subway in New York.

1906 Picasso paints *Les Demoiselles d'Avignon*. Separation of church and state in France.

1904 30 works by Cézanne at the Salon d'Automne. Second Cézanne exhibition at Cassirer in Berlin.

1905 Vollard exhibits Cézanne's watercolors in his gallery. Ten of Cézanne's paintings are exhibited at the Salon d'Automne.

1906 Vollard exhibits 12 paintings by Cézanne. Cézanne sends ten paintings to the Salon d'Automne. Out walking, Cézanne is overtaken by a storm and is not found till hours later, after collapsing in the street. On October 22 he dies in his apartment in Aix-en-Provence.

Opposite:
The Large Bathers (detail)
1894–1905
Oil on canvas
136 x 191 cm
London, National Gallery

Right:
Bather with Arms Behind His Head
ca. 1900
Pencil and opaque white on paper
20.4 x 12.6 cm
Basel, Öffentliche Kunstsammlung, Kupferstichkabinett

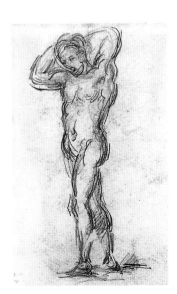

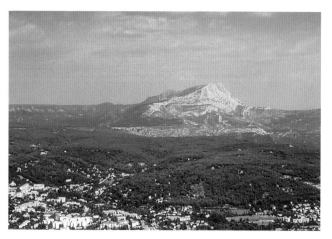

Images of a Mountain

Mont Sainte-Victoire, a 1,000-meter (3,280-feet) high limestone ridge that stretches in a long band across the Aix region, was one of the dominant themes in Cézanne's last years. Sixty paintings, drawings, and watercolors are dedicated to this subject alone. Even in the 1880s he had painted the mountain several times. In these early paintings, he was still using the mountain as the boundary of a broad plain, thus committing himself to the traditional landscape view with a deep perspective. In general, there were trees in the foreground, or the rocks of the Bibémus quarry, so that there was a clear transition to the mountain in the background, which appears here as an equal element of the picture.

Not till the later pictures, which were executed during a renewed examination of this theme after

The Landscape round Aix-en-Provence with the Mont Sainte-Victoire

Paul Cézanne at work
Photograph, 1904

Even in the final years of his life, Paul Cézanne seldom allowed the weather to prevent him from working in the open. Though he no longer walked to his vantage points, but often allowed himself to be driven there.

about 1900, did the mountain ridge itself become the dominant element.

Even the image of the mountain changed over the years: while the views of the peak from the Bibémus quarry show it as a broad mass, from a later viewpoint, to the west, on the Plateau d'Entremont, not far from the new studio on the Chemin des Lauves, the peak appears as a steeply sloping cone. At least eight paintings of the mountain show the peak from this angle – works whose high degree of abstraction made them so fascinating for following generations of artists.

Cézanne, who was to be seen painting in the same spot month after month, sometimes year after year, became an institution for the peasants of the region. Sometimes he concentrated so intensely on the theme preoccupying him that he would actually forget the canvas itself when it was time to go home,

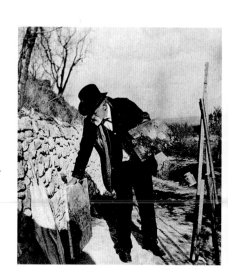

Auguste Renoir
Mont Sainte-Victoire
1889
Oil on canvas
53 x 64 cm
New Haven, Yale
University Art Gallery,
Catherine Ordway
Collection

In this painting,
Renoir tackles one of
Cézanne's main
themes. He did not
allow himself to be
influenced by his
friend's very
distinctive style,
however. Here the
atmosphere of a
landscape flooded
with light is
represented in a
typically

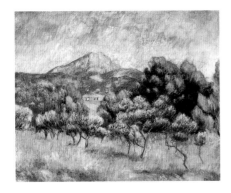

Impressionist manner,
with every detail
reflecting glittering
sunlight. The use of
warm colors in the
foreground and cool
violet tones in the
background (the sky)
produces a strong

effect of perspective.
This effect is also
heightened by the
mountain on the
horizon, which is
reached by the
diagonal formed by
the row of small trees
in the foreground.

and leave it on the spot where he had been working.

Before Cézanne, other Provençal painters had already taken an interest in this distinctive mountain. In 1849, François-Marius Granet, after whom the museum in Aix-en-Provence was later named, had studied this theme with similar obsession, sketching and painting it repeatedly. Renoir visited Cézanne several times in Aix-en-Provence, and in the summer of 1889 they spent a great deal of time working together on this theme. After Cézanne's death, many artists, fully aware of his legacy, came to the region to dedicate themselves to the now-famous mountain.

**Mont Sainte-
Victoire and the
Château Noir**
1904–1906
Oil on canvas
65.6 x 81 cm
Tokyo, Bridgestone
Museum of Art,
Ishibashi Foundation

In spite of the
relatively large flecks
of color that structure
the surface of the
painting, and which
are typical of
Cézanne's later work,
the subject is clearly
defined. The use of
dark colors in the
foreground, and pale
blue tones in the
distance, creates an
impression of depth.

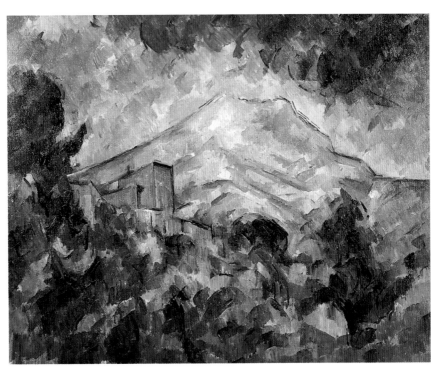

Mont Sainte-Victoire

I have painted a flat plane, as I paint nothing that I do not see.

Paul Cézanne

The repeated struggle with one and the same theme was characteristic of Cézanne's work. When, during the last years of his life, he repeatedly returned to the same spot from which he could contemplate Mont Sainte-Victoire, it was because he wanted to concentrate on viewing the mountain perceptually.

For Cézanne, painting was not a matter of copying reality but of creating a sculptural equivalent of his visual perception. He was thoroughly aware of the traditional rules of perspective in painting. A three-dimensional space can be simulated by using lines running to a central point in the distance. Similarly, light colors at the blue end of the spectrum seem far away, warmer colors seem closer.

In the early version of this theme, *Mont Sainte-Victoire* (below), the impression of distance is created in precisely this way. The mountain appears in a transparent blue, while the foreground contains stronger, warmer colors. But Cézanne wanted to free himself of this rational way of constructing a landscape, which is based on an understanding of perspective and color qualities, in order to reproduce what is seen by the innocent eye. In his unfinished painting, now in a Swiss private collection (top right), we can see how Cézanne proceeded: firstly

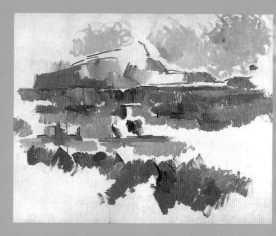

Mont Sainte-Victoire from Les Lauves
1902–1906
Oil on canvas
54 x 73 cm
Switzerland, private collection

he sketched the outline of the mountain and marked a few areas of shadow; with a few horizontal and vertical strokes, he laid down the basic structure to be filled in with various shades of color.

In the Basel *Mont Sainte-Victoire* (opposite), we see the result: broad, interlinking patches of color that are not intended simply to reproduce the actual color and form of individual houses and trees, but to be part of the subtle pattern of colors and tones created by the entire picture. Although the individual strokes of color are large enough to be distinguished individually, the subject is still recognizable, constructed solely from the color contrast and almost without

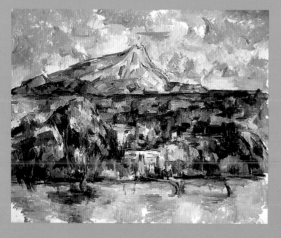

Mont Sainte-Victoire
1885–1887
Pencil, gouache, and watercolor
54 x 71 cm
Cambridge, Harvard University Art Museums, Fogg Art Museum

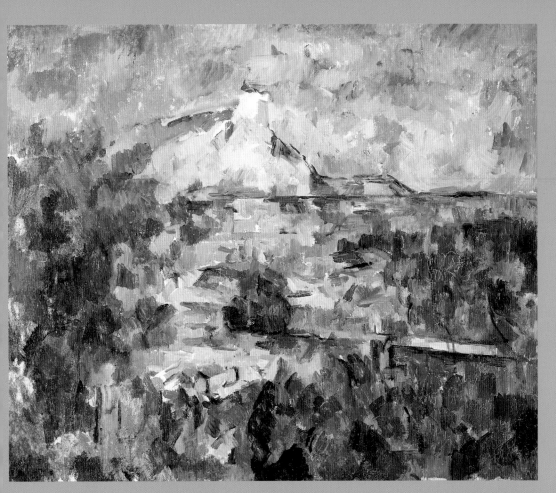

contour lines. In the left part of the painting, the fore-, middle- and background merge into one another and obscure the effect of perspective. Yet the houses in the middle ground, for example, can be clearly identified in a light, luminous area. The ochre of the sun-drenched plain is like a band of light across the pictorial planes leading to the mountain. The areas of shadow are marked by dark violet tones interspersed with red and green, and stand out in sharp contrast to the cool blue of the mountain. Cézanne uses this intense blue, which is the dominant color in almost all the paintings of the mountain – in this Basle version blue strokes of color extend right into the foreground – to produce the effect of distance; as he expressed it: "One must add enough blue to make the air tactile."

Cézanne had found an innovative way of drawing the observer's attention to the very act of perception, and so of questioning the traditional, representational form of landscape painting.

Mont Sainte-Victoire from Les Lauves
1904–1906
Oil on canvas
60 x 72 cm
Basel, Öffentliche Kunstsammlung, Kunstmuseum

The Late Portraits

Cézanne proceeded with his portraits in the same way as with landscapes and still lifes. Precise observation of the subject was for him an essential pre-requisite for painting. The young poet, Joachim Gasquet (page 67), recounted that Cézanne normally began painting a portrait after the model had left; he used the sitting to study the features in detail.

Gasquet's account of a portrait-sitting with his father illustrates Cézanne's usual procedure: "Most of the time, although he had his brush and palette in his hands, Cézanne was simply observing my father's face; he examined it very closely. He did not paint. From time to time a quivering application of the brush, and thinly applied brushstroke, a living blue to sketch in his expression, lay bare and define a fleeting character trait."

And he added: "He had a memory for colors and lines like no one else. With a lack of pretension similar to that of Flaubert, he stubbornly compelled himself to observe even the slightest detail of reality."

After Cézanne had moved into his studio on the Chemin des Lauves, he also began to paint portraits in the open. Peasants and day laborers from the surrounding areas sat as models for him on the terrace of the studio building. In the last year of Cézanne's life, he executed a whole series of portraits of his gardener, Vallier. The last ones, portraits painted in the summer of 1906, were undoubtedly the high point of Cézanne's portrait painting. Almost entirely without contour, the figure is constructed entirely by color, which is applied in irregularly sized, loosely applied brushstrokes. With their almost abstract technique, which consists of establishing form through areas of color, these last works may be compared with Cézanne's late paintings of Mont Sainte-Victoire.

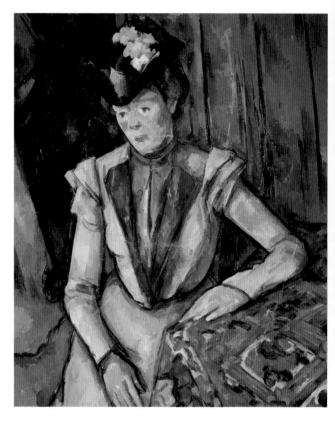

Woman in Blue
ca. 1904
Oil on canvas
88.5 x 72 cm
St. Petersburg,
Hermitage

It is thought that the woman portrayed here was Cézanne's housekeeper, Mme. Brémond. Compared with others who sat for Cézanne, the woman is dressed very elegantly and her features are clearly defined.

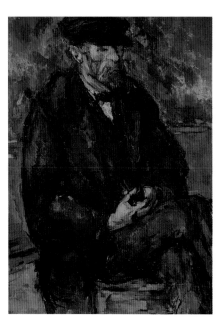

Portrait of Vallier the Gardener (The Seafarer)
1905
Oil on canvas
107.4 x 74.5 cm
Washington, The National Gallery of Art

It is only at first sight that this portrait of the gardener Vallier, dressed as a seafarer, appears somber and impenetrable. On closer consideration, the strong color tones emphasizing the face, hands, and the lower part of the seat fade. The color reappears with the line running along the end of the wall in the middle ground of the painting. The dominant green of the background, on the other hand, finds an echo in the floor to the left and in various parts of the material of the suit. While this clearly differentiates the various levels of the painting, the association of color and form is closely interwoven, reducing the monumentality of Valliers' presence. There is little similarity among the separate portraits of Vallier, though the face is seldom as clearly recognizable as it is in this painting.

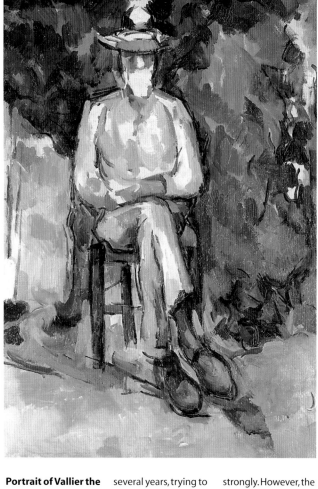

Portrait of Vallier the Gardener
1902–1906
Oil on canvas
107.4 x 74.5 cm
Zurich, E.G. Bürhle Collection

Among Cézanne's last major paintings, this portrait of Vallier is particularly prominent. Cézanne worked on it for several years, trying to achieve a perfect harmony between the figure and his surroundings. The gardener is emphasized by strong black lines, and even the light areas, through some of which the white canvas shows, make the figure stand out strongly. However, the limited range of colors link the various elements of the painting, so that they appear in harmony. A gardener was particularly appropriate to the theme of merging boundaries between man and nature.

Cézanne's *Bathers*

Between the 1870s and the end of his life, Cézanne explored the theme of bathers in over 200 oil paintings, watercolors, drawings, and lithographs. For the figures, he used a sketching technique that he had acquired when life drawing at the Académie Suisse, or in the Louvre copying Old Masters – these pictures were never executed in the open.

The theme itself was not original to Cézanne; the representation of people in a natural surrounding has a long tradition. In the Louvre, Cézanne must have studied works by Giorgione, Titian, Rubens, and Poussin that feature nude figures by water; these were ostensibly portrayals of religious and mythological scenes, though the main aim was to depict the beauty of the human (almost inevitably the female) body. Manet and Renoir still portrayed naked woman as images of sensual and erotic beauty. Generally, this subject also expressed a desire to represent man and nature in harmony. The idyllic natural scenery embodied the perpetual dream of an earthly paradise.

In his exploration of the bathers theme, Cézanne

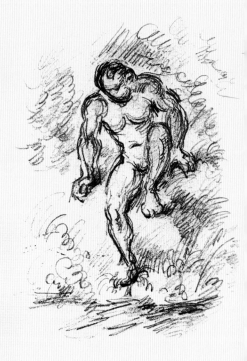

Above:
Male Nude Sitting in Waterside Undergrowth
1886–1889
Pencil on paper
19.4 x 11.8 cm
France, private collection

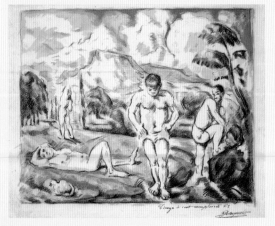

The Large Bathers
1896–1898
Watercolor lithograph
41.9 x 53.5 cm
Ottawa, The National Gallery of Canada

moved away from this approach by concentrating entirely on the setting – in other words, on the situation of being surrounded by nature. He was not concerned with physical beauty: his bathers have heavy, often deformed bodies, characteristics often attributed to his supposed lack of skill. They lack human expression and seem to have no connection with each other or to converse with one another, as would be

expected in this type of situation.

As in no other area of his creative output, the countless variations on bathers makes it possible to reconstruct Cézanne's attempt to create a complete composition from the point of view of both color and structure. The lithograph *The Large Bathers* (opposite, bottom left), for which designs already existed in the 1870s, is similar in construction to classical treatments of this theme, with its landscape extending into the depths of the picture. In the drawing *Male Nude Sitting in Waterside Undergrowth* (opposite, top right), Cézanne is concerned with the moment in which the man approaches the water in the foreground. In *Three Bathers* (above), the landscape has the same value as the figures. The colors of the figures are repeated in the landscape, a method Cézanne used to create a self-sufficient composition. An important element of this development is demonstrated in the picture *Male Bathers* (below); here, as so often in Cézanne's work, the small vertical brush strokes bring the individual elements of the image into close relationship with one another.

It is clear that once Cézanne had hit upon a specific pose for his figures, he used it often in later pictures. Thus, the back view of the stretching figure on the left of the lithograph is found again in this later oil painting. Here, however, the figures are standing next to one another in a row, so that the image has less spatial depth. This increased flatness is also expressed in the rows of trees that seem to push into the picture from the sides and allow only a narrow glimpse into the undefined background. Cézanne's long commitment to this theme, which culminated in *The Large Bathers* of 1906 (page 85), clearly indicates the great significance it had for him. He considered the connection between body and landscape a great artistic challenge – perhaps the greatest of all.

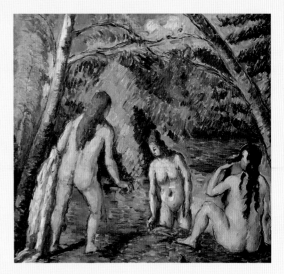

Three Bathers
1879–1882
Oil on canvas
52 x 55 cm
Paris, Musée du Petit Palais

Male Bathers
1890–1894
Oil on canvas
22 x 33 cm
Paris, Musée d'Orsay

The Large Bathers

Here, on the river bank, the themes are many: the same subject, seen from another angle, proves to be an object of study of extraordinary interest and of such diversity that I believe I could contemplate it for several months without changing position, just turning a little more to the right or to the left.

Cézanne in a letter to his son, 1906

In the last seven years of his life, Cézanne worked on three large paintings of female bathers. Even the size of the canvases he selected – apart from one version of *The Card Players*, these are by far the largest he painted – demonstrates the significance Cézanne placed on these paintings. After his decades of work on the nude figure, he wanted in his last years to expand his compositions to huge proportions and introduce more figures. He hoped that these monumental works would earn him a secure place in the great tradition of nude painting.

How the individual paintings were created is no longer clear. We know that Cézanne had been working on one of the paintings since 1894 and had probably begun a second by 1899. We presume that the painting in the Barnes Collection (below) was the first, followed by the painting in London (above and page 74), and that the version in the Philadelphia museum (opposite) was the last Cézanne painted. At a later stage he probably worked on all three paintings at the same time.

With the theme of the bathers, Cézanne set himself the task of creating a

Above:
Great Bathers
1894–1905
Oil on canvas
172.2 x 196.1 cm
London, National Gallery

Below:
Cézanne in front of *The Large Bathers*
(today in the Barnes Collection)
Photo Emile Bernard, 1904

harmonious link between figures and landscape. Here, too, Cézanne was not interested in the individuality of the separate figures, but in their form. This means that the figures do not stand out as the dominant element of the paintings; they are incorporated into the overall composition so that they merge into their environment. In the Philadelphia version,

Cézanne achieved this by arranging the figures in two groups, both of them appearing to be restricted to a triangular area. This shape, closing in a point at the top, is reflected in the surrounding tree trunks, which frame the view into the background. In particular, the color co-ordination between the figures and the landscape enhances the merging of the two main elements of

the painting. Thus, the skin tone of the bathers in this version is only a slightly lighter shade of the ochre-beige of the riverbank they are sitting on. The lighter parts of their bodies (here the unpainted canvas can often be seen) are reflected, from a compositional point of view, in the white of the large cloud in the center of the painting. The color of the bathers' hair, too, reflects the natural setting, repeating as

it does the brown of the tree trunks. These chromatic links allow the bathers to merge into the forms of nature.

The Large Bathers
1906
Oil on canvas
208.5 x 249 cm
Philadelphia, Museum of Art, W.P. Wilstach Collection

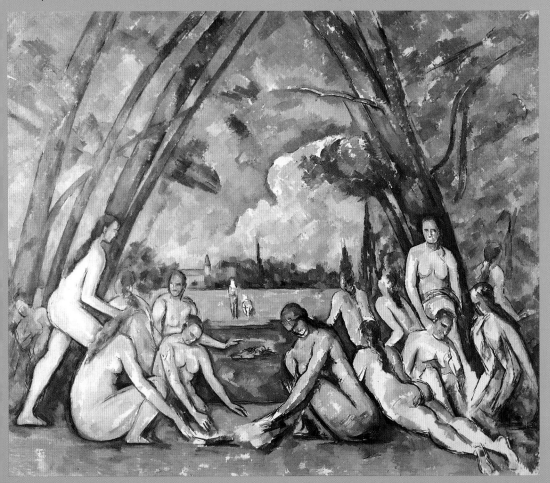

The Father of Modern Art

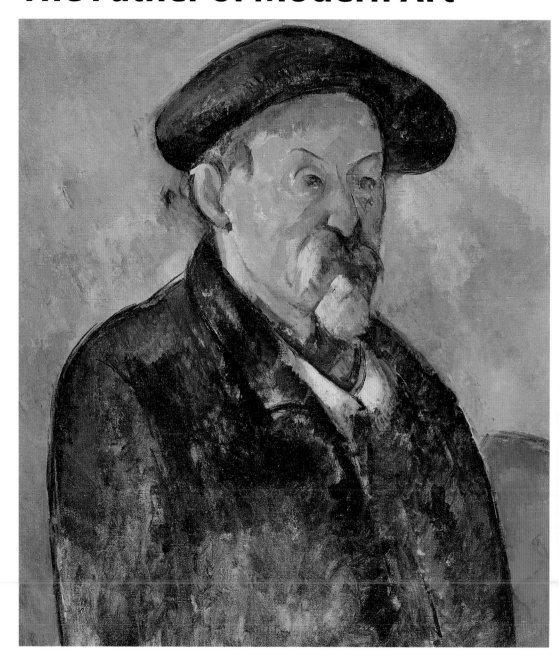

Cézanne's paintings, particularly his late master-pieces, had a profound impact on the art of the 20th century. Some of the most important repre-sentatives of modern painting – among them Gauguin, Matisse, Picasso, Braque, Delaunay, Mondrian, Malevich, Bizaine, Klee, Baumeister, Ad Reinhardt, Kirkeby, Jasper Johns – have described Cézanne as the most important precursor in their own development. For by the early years of the 20th century, Cézanne's new approach to space and his rejection of the conventional rules of perspective had brought art to a completely new point of departure.

Three retrospectives shortly after Cézanne's death helped to bring about his recognition as a major artist. Critics and public now had a chance to see his work as a whole. First there was an exhibition of his works at the Salon d'Automne of 1906, held shortly after Cézanne's death, and to which he had himself sent paintings. And then there were two retrospectives the following year: in June 1907, the Galerie Bernheim-Jeune exhibited 79 of Cézanne's watercolors; and a few months later a memorial exhibition was held in two rooms at the Grand Palais in Paris, showing 49 paintings and seven watercolors.

Opposite:
Self-Portrait with Beret (detail)
1898–1900
Oil on canvas
63.3 x 50.8 cm
Boston, Massachusetts, Museum of Fine Arts

Flat-Iron Building, New York, 1902

Cézanne in 1904

Important paintings influenced by Cézanne:

1904–1905 Henri Matisse: *Luxe, Calme et Volupté*

1907 Pablo Picasso: *Les Demoiselles d'Avignon*

1908 Georges Braque: *Viaduct at L'Estaque*

1910 Wassily Kandinsky: *Landscape with Factory Chimneys*

1912 Robert Delaunay: *The City of Paris*

1917 Lyonel Feiniger: *Bathers II*

1922 Piet Mondrian: *Composition in Red, Yellow and Blue*

1952 Jean Bazaine: *Tree and Wave*

1959 Ad Reinhardt: *Abstract Painting*

1977 Jasper Johns: *Tracing after Cézanne*

Major Cézanne Exhibitions:

1907 Paris, Salon d'Automne

1909 Berlin, Galerie Paul Cassirer

1910 Paris, Galerie Bernheim-Jeune

1916 New York, Montross Gallery

1925 London, The Leicester Galleries

1927 Berlin, Galerie Thannhauser

1929 New York, The Museum of Modern Art

1936 Paris, Musée de L'Orangerie. Basel, Kunsthalle

1942 New York, Paul Rosenberg Gallery

1953 Aix-en-Provence, Pavillon de Vendôme

1974 Tokyo, Musée National d'Art Occidental

1988 London, Royal Academy of Arts

1993 Tübingen, Kunsthalle

Cézanne and Cubism

Just after the turn of the century several young artists started exploring the potential of Cézanne's achievements, among them Derain, Gris, Matisse, Braque, and Picasso.

Two retrospectives in 1907, the year following Cézanne's death, provided the first comprehensive view of his development, and contributed greatly to the increasing respect with which Cézanne was held among young artists.

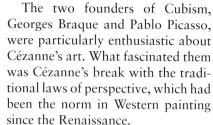

Georges Braque
Viaduct at L'Estaque
1908
Oil on canvas
72 x 59 cm
Paris, Musée d'Art Moderne

In Cubist composition, space does not develop in the depths of the painting but seems to move outwards towards the observer. Here, Braque painted the same theme Cézanne had painted in his *Monte Sainte-Victoire* of 1882 (page 46).

The two founders of Cubism, Georges Braque and Pablo Picasso, were particularly enthusiastic about Cézanne's art. What fascinated them was Cézanne's break with the traditional laws of perspective, which had been the norm in Western painting since the Renaissance.

As early as the winter of 1906, Braque had visited L'Estaque. He traveled there again in Cézanne's footsteps the following summer and sought out Cézanne's themes, such as the view over L'Estaque bay from the bend in the road. Under Cézanne's influence, Braque began to develop a completely new approach to painting. Cézanne's way of breaking up the contours of objects so that they flowed into adjacent pictorial areas was particularly significant. In his *Viaduct in L'Estaque* (left), for instance, Braque merges the surfaces of the house roofs into one another so that no obvious focal point is discernible. Here the distortion of perspective in favor of a shifting focal point, a keynote of Cubism, is also already apparent.

In the summer of 1908 Picasso also began painting landscapes in the style of Cézanne. From the autumn of 1908, Braque and Picasso worked together closely and, in close collaboration, continued the development of what Braque had begun in L'Estaque. However, Cézanne had represented his subjects both from above and from the front, to illustrate what he considered to be the real process of perception: he thought

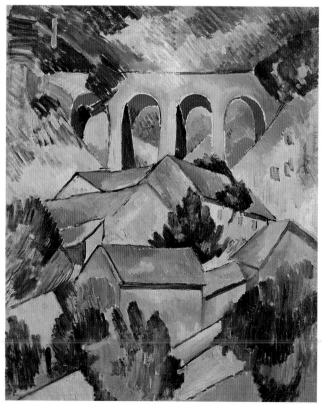

the fact that we have two eyes means that we see an object from two slightly different angles at the same time. The Cubists, by contrast, were questioning human perception itself. By breaking up the surfaces of objects into individual facets and representing the components of an object simultaneously from every side, they wanted to underline the relativity of all perception. To do this, they contrived an almost scientific analysis of their subjects, using multiple viewpoints and stressing geometrical form. This took them far beyond Cézanne; yet without his work Cubism would have been unthinkable.

If one enlarges certain parts of Cézanne's paintings... one notes a rhythmic texture which could be called cubist and which was taken over by Cubism.

Willi Baumeister

Juan Gris
The Tobacco Pouch
1916
Oil on canvas
46 x 38 cm
San Francisco, John
Bergruen Gallery

In this picture, which may be attributed to the later phase of Cubism, known as Synthetic Cubism, illusory methods bring visual perception into question. Here the wood grain contrasts with the multi-facetted still life.

Pablo Picasso
Portrait of Ambroise Vollard, 1910
Oil on canvas
93 x 66 cm
Moscow, State
Pushkin Museum for
the Fine Arts

The art dealer Ambroise Vollard, who had already made Cézanne famous with his exhibitions, also recognized the significance of Picasso and Braque at an early stage. This portrait was executed at the peak of the Analytical Cubist movement. In the countless facets of the fractured surface, simultaneously planar and three-

dimensional, only the shape of the subject's body can be made out. Nevertheless, the subject is still recognizable. In this form of Cubism, details stand out from the surface, and faces, often almost caricatures, are composed of a few lines. Thus in his portrait of Vollard, Picasso did not omit to portray his high brow and characteristic nose, features already apparent in Cézannes *Portrait of Ambroise Vollard* of 1899 (page 64).

The *Bathers* in the 20th Century

Cézanne's bathing scenes were totally alien to his contemporaries. Because of the frequently uncouth-looking figures, many people chose to believe that he did not in fact have the skill to depict graceful, true-to-life figures.

For many contemporary artists, however, his work was a revelation: through his experience of Impressionism and its painting technique, which he had developed in his own distinctive way, Cézanne had taken painting in new directions.

The younger painters admired the manner in which he interconnected figures and their setting, both through color and structure. Particularly through his *Bathers*, Cézanne made clear his view that art was no longer about producing illusory imitations of nature.

Individual figures and elements of these works have had a continuing effect on the art of the 20th century. Many have seen his portrayal of nude figures in various groupings as a particularly interesting challenge. Picasso's *Les Demoiselles d'Avignon* (below) is not alone in being linked with the later versions of Cézanne's *Bathers*. Many other important artists, from Matisse to Henry Moore, have grappled with Cézanne's concept of physical volume. Matisse owned Cézanne's painting *Three Bathers* of 1879–1882 (page 83) for

Pablo Picasso
Les Demoiselles d'Avignon
1907
Oil on canvas
234.9 x 233.7 cm
New York, The Metropolitan Museum of Art

When Picasso's friends saw this painting in 1907, they reacted with shock and confusion. Today it is valued as a key work in modern art. Five over life-sized, naked women stare at the observer and expose their bodies to view shamelessly and provocatively. But it is not just their manifest sensuality that shocks, it is above all the way they are painted. All shapes are angular and rough, as though hewn out by ax. Most striking are the faces of the two distorted women at the right side of the painting, their distinctive features barely human. Stylistically, Picasso is reaching back to Cézanne's version of *The Bathers*, renouncing all representation of depth and closely interweaving the planes of the composition.

three decades, turning the second figure from the left into a series of sculptures. In 1937, the year after the great Cézanne Retrospective in Paris, Matisse made a gift of this painting to the Musée du Petit Palais in Paris. He addressed the curator with a request that recorded how important this work was for him: "During the 37 years it belonged to me, I got to know this painting very well, and yet not as well as I would hope. In critical moments of my quest as an artist, it has given me courage: it supported my belief and my endurance. Permit me therefore to request that you give it the place it deserves to fully come into its own."

André Derain
Bathers
1908–1909
Oil on canvas
33 x 41 cm
Private collection

Nude figures form a dominant theme in works of the French painter André Derain, scenes of bathing often providing the setting. After the major Cézanne Retrospective of 1907, he based his color schemes on the palette employed by Cézanne.

Henri Matisse
Luxe, Calme et Volupté
1904–1905
Oil on canvas
98.3 x 118.5 cm
Paris, Musée d'Orsay

Matisse combined the theme of bathers from his great exemplar Cézanne, with Manet's image of *Le Déjeuner sur l'herbe* (page 27). He worked particularly on the color, which he applied in closely juxtaposed brush strokes, and through which he represented a scene flooded with light and almost entirely without contours.

Glossary

Academy: An art school where, in addition to the technical skills of the creative arts, the currently relevant artistic concepts of the period are also taught. A point of departure for the discussion of concepts such as beauty, imitation of nature, etc., and therefore for innovations in art.

Allegory: The use of images or narrative to convey an abstract concept.

Avant-garde: The artists who are in advance of their time, who anticipate new developments.

Commune of 1871: An insurrection in Paris (March 18-May 28) following France's defeat in the Franco-Prussian War. The aim was to have popular government. The insurrection was quickly suppressed by government troops.

Composition: The art of combining the elements of a picture into a satisfying visual whole. The elements include color, form, line, symmetry and asymmetry, movement, rhythm, etc.. In landscape painting, an important element of composition is the arrangement of the pictorial planes, i.e. the methods used to inter-relate the fore-, middle- and background.

Contour: The outline of an object painted as a line or as a contrast between two areas of color or tone.

Cubism: An art movement founded by the Spanish artist Pablo Picasso and the French artist Georges Braque (from about 1907). In Cubism objects are no longer depicted as straightforward representations, seen from a single point of view, but as a collection of images representing a multiplicity of views.

In *Analytical Cubism* (ca. 1910 - 1912) images are broken down into collections of small, usually geometrical, planes or facets; in *Synthetic Cubism* (ca. 1912-1915, with echoes until well into the 1920s), there are far fewer planes, the colors are brighter, and collage is often used.

Franco-Prussian War: War fought July 1870 to May 1871 between Prussia, which was attempting to secure its western border, and France. France was defeated and Paris briefly occupied.

Genre painting: A form of painting that represents scenes from daily life. This was seen as a "lower form" of art and was often characterized by the high degree of realism. There are distinctions between the peasant, middle-class, and court genres. Genre painting achieved its highpoint during the 17th century, in the everyday scenes of Dutch painting.

Gouache: A painting technique using water-based paints that are opaque (in contrast to watercolor). By intermixing binding agents and opaque white, a pastel-color effect is achieved, the paint drying to a matte finish.

Idyll: A painting depicting an idealized life of rural simplicity.

Illusionism: Painting that strives for a high degree of detailed realism. This is usually achieved through the use of perspective effects and exact modeling, creating an illusion of three-dimensionality.

Impressionism: An art movement that began about 1870 in France. The essence of Impressionism was the desire to capture the appearance of an object or scenes at a precise moment. Characteristic of Impressionism are free brushwork, light colors, and subjects which are casual, everyday scenes. Impressionists usually painted out of doors and preferred landscapes and scenes of urban life.

Landscape painting: Landscape developed into an independent form of painting at the end of the 16th century. In the 17th century, so-called "ideal landscapes" were executed (e.g. Claude Lorrain's poetic landscapes), as well as the "heroic landscapes" (e.g. Nicolas Poussin's allegories). Landscape painting flourished during the Dutch Baroque. Landscape painting was revolutionized by the advent of painting in the open during the 19th century.

Motif: The main idea, subject, or theme of a work.

Mythology: Ancient myths of gods and heroes; since antiquity, mythology had been a favorite theme for artists. Rediscovered during the Renaissance, classical mythology became an important and inexhaustible source of many themes in Western art.

Neoclassicism: An art style that flourished between 1750 and 1840, based on classical antiquity, particularly the art and architecture of ancient Greece. Neoclassical painting is typified by its light colors and sharp outlines. One of its leading figures was the French painter Jean-Auguste-Dominique Ingres (1780-1867).

Oil painting: A painting technique in which the color pigment (ground color) is bound with oil. Oil paint is creamy in texture, is easily mixed, and dries slowly. Oil painting was introduced in the 15th century and soon became the most widely used painting technique.

Perspective: Any method of representing three-dimensional objects on a flat surface; perspective gives a picture a sense of depth. The most important form of perspective is *linear*

perspective (first formulated by the architect Brunelleschi in the early 15th century), in which the real or suggested lines of objects converge on a *vanishing point* on the horizon. The use of linear perspective had a profound effect on the development of Western art and remained unchallenged until the 20th century. *Aerial perspective* is a way of suggesting the far distance in a landscape by using paler colors (sometimes tinged with blue), less pronounced tones, and vaguer forms.

Pictorial plane: In painting, a vertical plane which, parallel to the picture plane, indicates distance. In paintings aiming to give an impression of depth, the surface is divided into three pictorial planes: a foreground, a middle ground, and a background. These will be clearly separated from each other through the use of color and design, figures and objects, or they may merge into one another. See Composition

Plein-air **painting**: Painting executed in the open, in contrast to in the studio. This technique was first used in the mid-19th century by the French Barbizon School and then mainly by the Impressionists.

Portrait: A representation of an individual or individuals. The distinction is made between self, individual, double, and group portraits.

Putto (plural **putti**): In painting and sculpture, plump naked little children, usually boys, most commonly found in late Renaissance and Baroque works. They can be either sacred (angels) or secular (the attendants of Venus).

Retrospective: An exhibition that presents a comprehensive selection of an artist's works, usually from all period's of his or her development.

Romanticism: An artistic and literary movement beginning in the early years of the 19th century. The Romantics placed strong emphasis on intense feeling, individuality, and imagination. Brooding landscapes were characteristic, as was the return to the medieval world of saga and poetry. Artists associated with Romanticism include J.M.W. Turner in Britain, Caspar David Friedrich in Germany, and Théodore Géricault and Eugène Delacroix in France.

Salon: In 19th-century French art, major exhibitions, usually held annually. Examples include the official Salon, the Salon des Independants, and the Salon des Refusés.

Still life: A portrayal of inert articles such as fruit, dead animals, flowers, or everyday objects. Still lifes are often of a symbolic nature, particularly in older schools of paintings.

Study: A preparatory drawing for a painting or sculpture. Executed in a wide variety of techniques, the degree of completeness of a study ranges from a fleeting sketch of various physical postures or other elements of the composition, to a detailed, artistically formulated drawing.

Vanishing point: See Perspective

Watercolor: Water-soluble paint which dries to a transparent finish, and therefore has a particularly light, delicate effect.

Index

Acknowledgements

The publisher would like to thank the following museums, archives, and photographers for their permission to use reproductions and their kind support in the completion of this book.

© Archiv für Kunst und Geschichte, Berlin: 4 b l, 7 a l, 9 r, 13 a l (photo Beard, London), 23 a l, 26 b, 27 b, 31 a l, 32 b, 34 a l, 34 r, 35 a, 36 a l/b, 37 a/b, 38 b, 41 a l/b, 44 a, 46, 48, 49 a l, 50 b, 52 a, 59 b, 60 a, 63 a l, 64 b, 78 b, 80, 87 a r/a l, 89 b, 90; (photos: Erich Lessing) 26 b, 34 r, 43 b, 44 b, 47 b, 54 a, 91 b, back cover.

© Artephot, Paris: (Sirot-Angel Coll.) 5 a l, 30, 76 b; (photo Maurice Denis) 84 b; (Niarchos/André Held Coll.) 49 a r.

© Artothek, Weilheim: 29 a/b, 47 a, 51; (photo Joachim Remmer) 53 b; (photo Joseph S Martin) 55; (photos Peter Willi) 2, 59 a, 70 b, 88; (photos Hans Hinz) 50 a, 61 r, 65 a, 79.

© Atelier Paul Cézanne, Aix-en-Provence: 72 b (photo François Colin) 73 a (photo Michel Fraisset).

© Achim Bednorz Cologne: 14 a.

© Bibliothèque nationale de France, Paris: 17 l, 38 a.

© Bildarchiv Preussischer Kulturbesitz, Berlin 1999: 4 b r, 62.

© The Bridgeman Art Library, London: 4 a r, 5 b l, 8 a, 21 b, (Roger-Viollet) 22, 24 a, 25 b, 33 a/b, 41 a r, 42 a, 45 b, 57 b, 63 b, 65 b, 66 a, 70 a, 71, 74, 83 a, 84 a, 85; (Lauros-Giraudon) 13 a r, 64 a, 66 b, 73 b, 78 a (Peter Willi/BAL) 39 a/b, 54 b, 56, 57 a; (Giraudon/BAL) 19 b, 52 b, 58, 77 b.

© Bullot, Paris: 10 a, b l, b r, 16 r.

© Christie's Images, London: 68 a/b, 69, 91 a.

© The Fitzwilliam Museum, Cambridge: Cover, 5 a r, 40

© Kharbine-Tapabor Collection, Paris: 20 a.

© By kind permission of the Provost and Fellows of King's College Cambridge: 24 b.

© Musée Calvet, Avignon: 13 b.

© Museum of Fine Arts, Boston, Charles H. Baylay Picture and Painting Fund and Partial Gift of Elizabeth Paine Metcalf: 5 b r, 86.

© Národní Gallery, Prague: 67

© Board of Trustees of the National Gallery, London: 4 a c, 12

© 2005 Tandem Verlag GmbH
KÖNEMANN is a trademark and an imprint of Tandem Verlag GmbH

Editor: Peter Delius
Series concept: Ludwig Könemann
Art director: Peter Feierabend
Cover design: Claudio Martinez
Concept, editing and layout: Barbara Delius
Picture research: Jens Tewes, Florence Baret

Original title: Paul Cézanne. Leben und Werk
ISBN 3-8331-1067-8 (original German edition)

© 2005 for the English edition: Tandem Verlag GmbH
KÖNEMANN is a trademark and an imprint of Tandem Verlag GmbH

Translation from German: Phil Greenhead in association with Goodfellow & Egan
Editing: Chris Murray in association with Goodfellow & Egan
Typesetting: Goodfellow & Egan
Project management: Jackie Dobbyne for Goodfellow & Egan Publishing Management, Cambridge, UK
Project coordination: Nadja Bremse

Printed in China

ISBN 3-8331-1539-4

10 9 8 7 6 5 4 3 2
X IX VIII VII VI V IV III II I

Cover
View of L'Estaque and the Chateau d'If
1883–1885
Oil on canvas
71 x 57.7 cm
Cambridge, Fitzwilliam Museum
Loan from private collection

Page 2
Self-Portrait, ca. 1872
64 x 52 cm
Paris, Musée d'Orsay

Back Cover
Self-Portrait on Rose Background
ca. 1875
Oil on canvas
66 x 55 cm
Paris, Musée d'Orsay